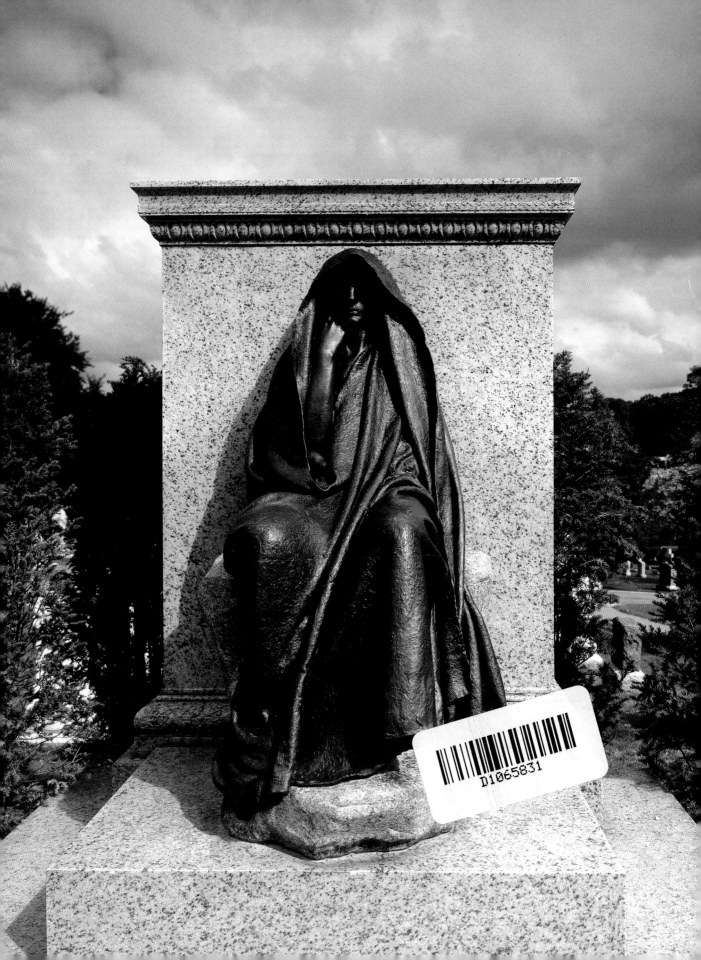

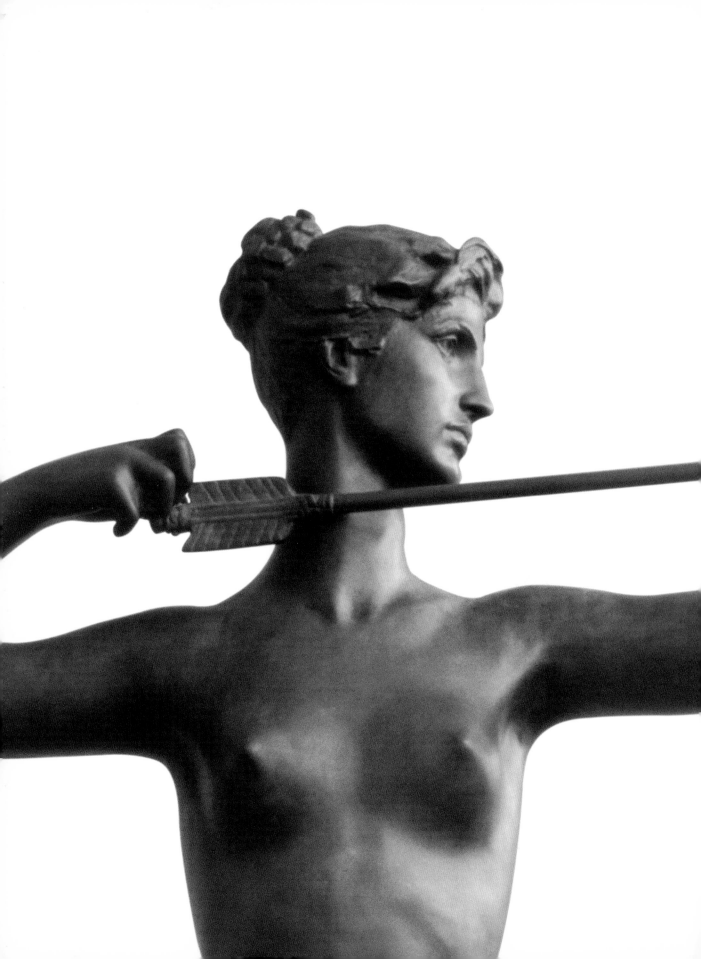

AUGUSTUS SAINT-GAUDENS

AMERICAN·SCULPTOR OF·THE·GILDED·AGE

**HENRY J. DUFFY AND JOHN H. DRYFHOUT
GUEST CURATORS**

TRUST FOR MUSEUM EXHIBITIONS, WASHINGTON, D.C.
IN COOPERATION WITH THE SAINT-GAUDENS
NATIONAL HISTORIC SITE, CORNISH, NEW HAMPSHIRE

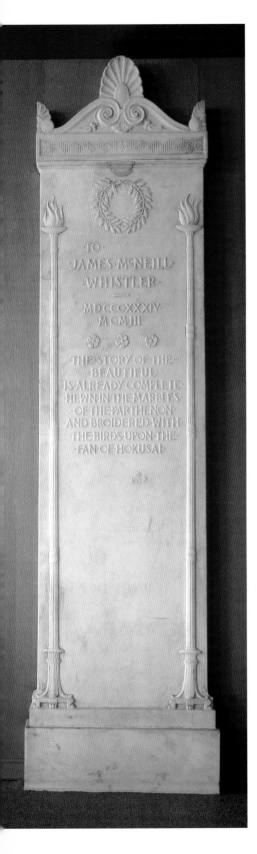

Trust for Museum Exhibitions
1424 16th Street, N.W.
Washington, D.C. 20036

ISBN: 1-882507-12-6

Prepared for publication by
Archetype Press Inc.
Diane Maddex, Project Director
Gretchen Smith Mui, Editor
Robert L. Wiser, Designer

Printed in Hong Kong

10 9 8 7 6 5 4 3 2 1

Unless otherwise indicated, all works pictured in this catalogue are by Augustus Saint-Gaudens (1848–1907).

FRONT COVER. *Sherman Monument, Victory,* 1897–1902.
BACK COVER. *Ceres Panel,* Cornelius Vanderbilt II House, New York City, 1881–83.
PAGE 1. *Adams Memorial,* 1886–91. Rock Creek Cemetery, Washington, D.C.
PAGES 2–3. *Diana, Second Version, Half Size,* cast 1972–73.
PAGE 4. *Whistler Memorial,* 1906–7. U.S. Military Academy, West Point, N.Y.
PAGE 5. *Standing Lincoln,* 1905. Lincoln Park, Chicago, Ill.
PAGES 6–7. *Sherman Monument,* 1892–1903. Grand Army Plaza, New York City.
PAGES 12–13. Saint-Gaudens and his Art Students League class, 1888. Saint-Gaudens National Historic Site, Cornish, N.H.
PAGE 120. *Shaw Memorial,* 1884–97. Boston Common, Boston, Mass.
PAGE 128. *The Puritan,* 1883–86. Merrick Park, Springfield, Mass.

Photograph Credits
Unless otherwise noted, all photographs of objects at the Saint-Gaudens National Historic Site in Cornish, N.H., are by Jeffrey Nintzel.
James Breese, 33; Lawrence Chamberlain, 70; Kevin Daley, 4, 6–7, 25, 50–51; John Evarts, 24 bottom; Carol Highsmith, 1; A. Janion, 107; Jeffrey Nintzel, 120, 128; Michael Stillman, 38; DeWitt Clinton Ward, 26

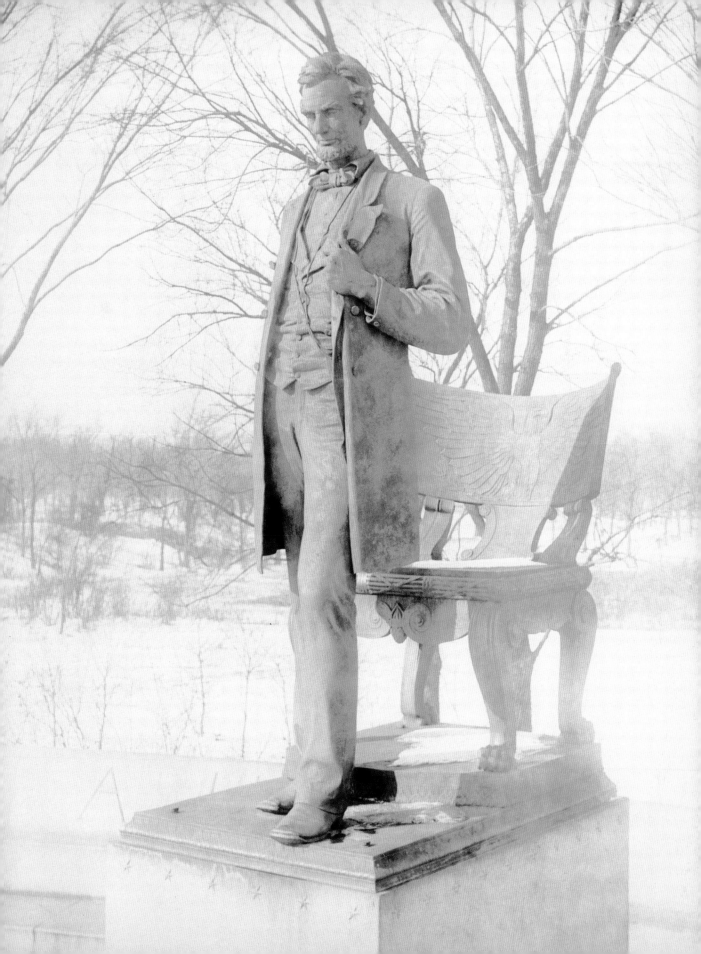

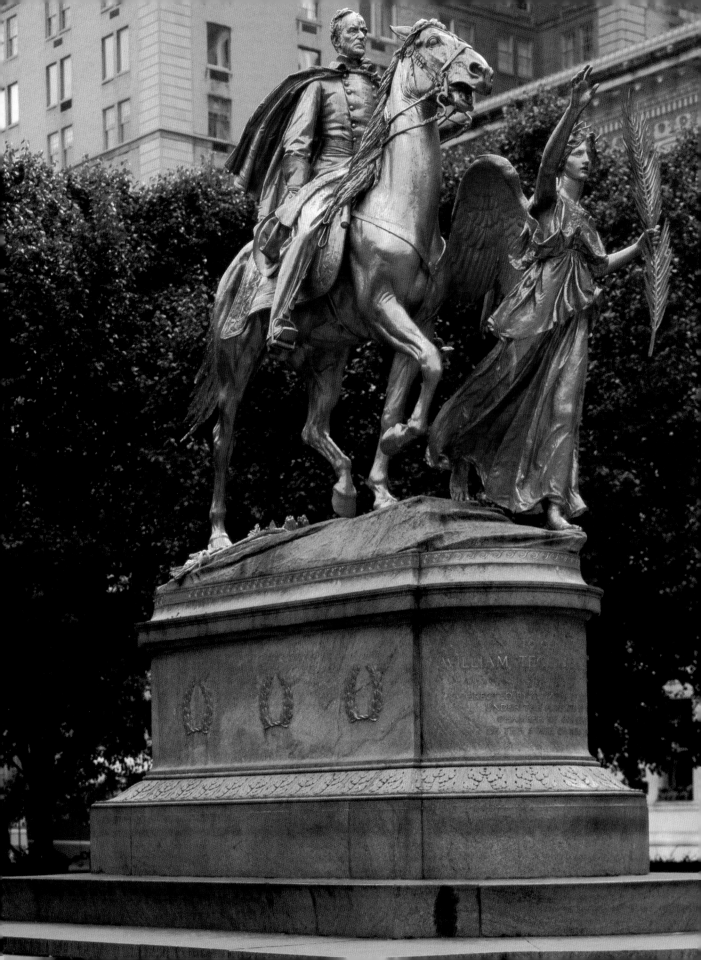

CONTENTS

ACKNOWLEDGMENTS

The Trust for Museum Exhibitions is honored and privileged to mount this historic tour of works of the incomparable Beaux Arts sculptor Augustus Saint-Gaudens. When I first approached John H. Dryfhout, superintendent of the Saint-Gaudens National Historic Site, with the idea for this tour, I dared not think he would permit TME to mount this historically significant exhibit, the first such traveling exhibition of Saint-Gaudens's works in this country. Yet today a full-scale retrospective of the master's work is going on the road!

Saint-Gaudens was educated in the United States and abroad, but it was his training in Paris that clarified his conception of ideal beauty, which relied heavily on French and Italian Renaissance art. His studio in Paris became a gathering place for many American artists, and it was there that he solidified a friendship with the architects Charles F. McKim and Stanford White. Saint-Gaudens's collaboration with White bore fruit in more than twenty cooperative projects that brought about a significant change from previous monumental sculpture produced in the United States. Siting, landscaping, and the monument's architectural features received their careful attention, with the result that the total plan and all other details—benches, pedestals, and inscriptions, among other features—formed an organized and integrated whole.

Touring exhibitions of monumental sculpture are rare, and we have legions to thank for this grand accomplishment. First, we wish to express our gratitude to the U.S. Department of the Interior and the National Park Service for their gracious cooperation in this endeavor. Special recognition must be given to the team at the Saint-Gaudens National Historic Site in Cornish,

8

New Hampshire—especially John Dryfhout, superintendent, and Henry J. Duffy, curator—for their superlative efforts in organizing this exhibition and writing the catalogue.

Credit for the exhibition's innovative design belongs to Didier Blin, who brought his French sensibility, taste, and knowledge of art history to the installation design, and to the North Carolina Museum of Art, which executed Mr. Blin's vision so faithfully in its construction of the installation furniture. We are delighted to have the North Carolina Museum of Art as a partner and as the opening venue for this special exhibit, and we are grateful to be collaborating with the eleven other host institutions on the tour.

We are also indebted to Archetype Press, Inc., including Diane Maddex, Gretchen Smith Mui, and Robert L. Wiser, for effectively conveying the stately beauty of our project in this elegant catalogue.

We cannot overlook the invaluable contributions of the TME staff, interns and volunteers, including Chief Registrar Christopher Whittington, who brought his organizational skills and professional expertise to the task of preparing the exhibition for transport on its long tour. Finally, we must thank Diane Salisbury, who has masterminded this exhibition at every turn. Her talent for organizing and editing has produced the fine product we celebrate here.

Ann Van Devanter Townsend
Chairman
Trust for Museum Exhibitions

ITINERARY

North Carolina Museum of Art, Raleigh, North Carolina
February 23–May 11, 2003

The Parrish Art Museum, Southampton, New York
June 5–August 3, 2003

Museum of the American Numismatic Association and the
Colorado Springs Fine Arts Center, Colorado Springs, Colorado
August 28–October 26, 2003

Allentown Art Museum, Allentown, Pennsylvania
November 20, 2003–January 18, 2004

Memorial Art Gallery, University of Rochester, Rochester, New York
February 12–April 11, 2004

Frick Art and Historical Center, Pittsburgh, Pennsylvania
May 6–July 4, 2004

Georgia Museum of Art, University of Georgia, Athens, Georgia
July 29–September 26, 2004

Montgomery Museum of Fine Arts, Montgomery, Alabama
October 21, 2004–January 2, 2005

Smith College Museum of Art, Northampton, Massachusetts
January 26–March 20, 2005

Wichita Art Museum, Wichita, Kansas
April 15–June 12, 2005

Center for the Arts, Vero Beach, Florida
July 7–September 5, 2005

Munson-Williams-Proctor Museum of Art, Utica, New York
September 29–November 27, 2005

LENDERS TO THE EXHIBITION

American Academy of Arts and Letters, New York, New York

The American Numismatic Society, New York, New York

Maria L. Bissell, Ponte Vedra Beach, Florida

Bowdoin College Museum of Art, Brunswick, Maine

Brooklyn Museum of Art, Brooklyn, New York

The Century Association, New York, New York

Fred Finn, Olympia, Washington

Robert Gordon, Plainfield, New Hampshire

Mr. and Mrs. William Hagans, Detroit, Michigan

Eben T. McLane, Maravia, New York

The Metropolitan Museum of Art, New York, New York

National Academy of Design, New York, New York

North Carolina Museum of Art, Raleigh, North Carolina

The Parrish Art Museum, Southampton, New York

Mrs. Henry Sherk, Philadelphia, Pennsylvania

U.S. Department of the Interior, National Park Service,
Saint-Gaudens National Historic Site, Cornish, New Hampshire

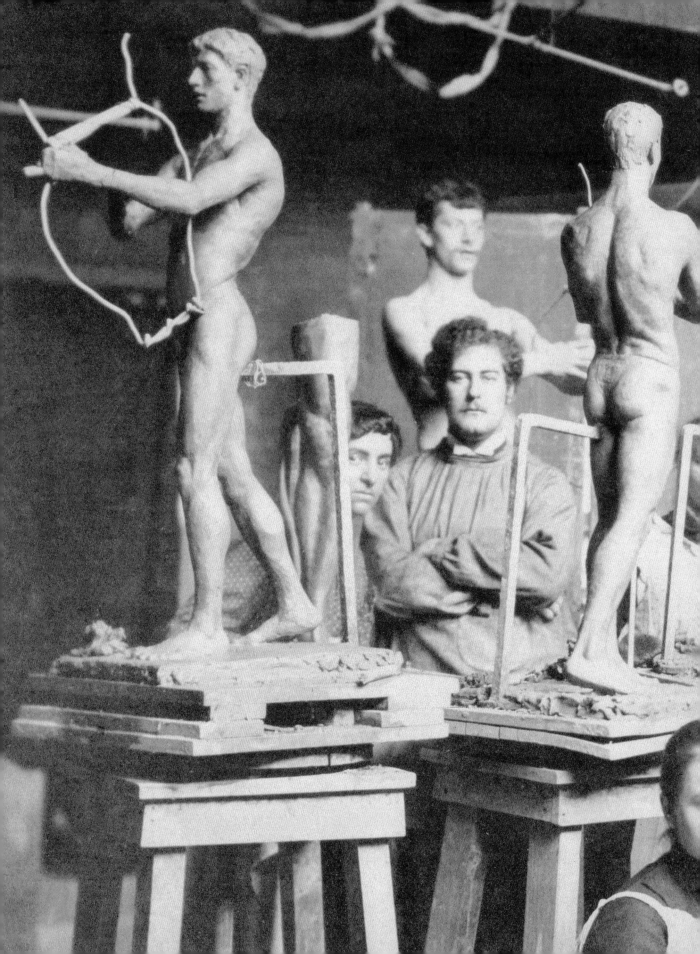

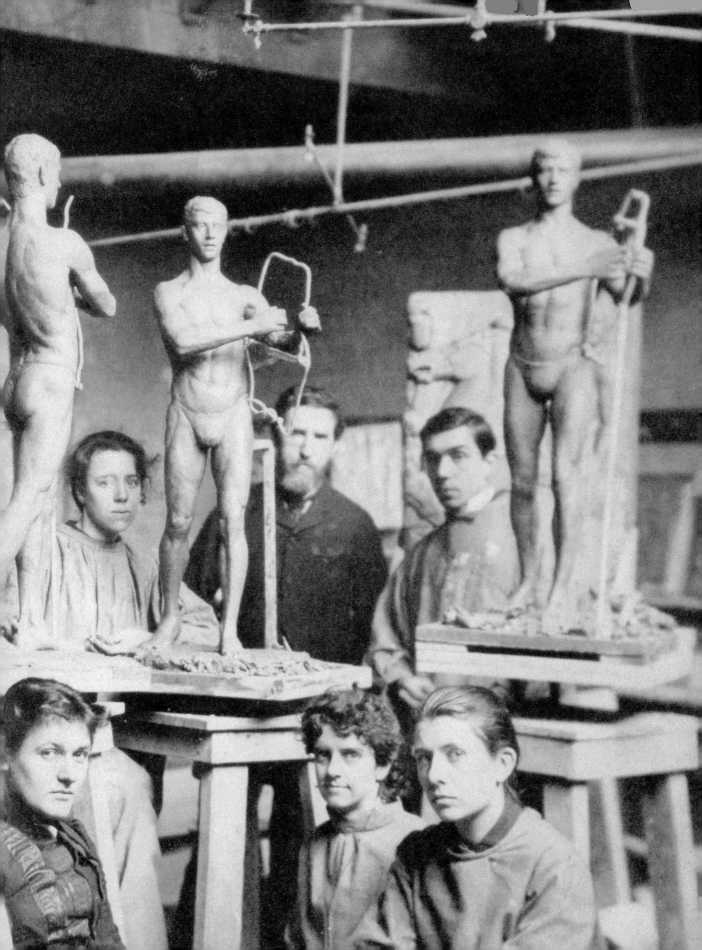

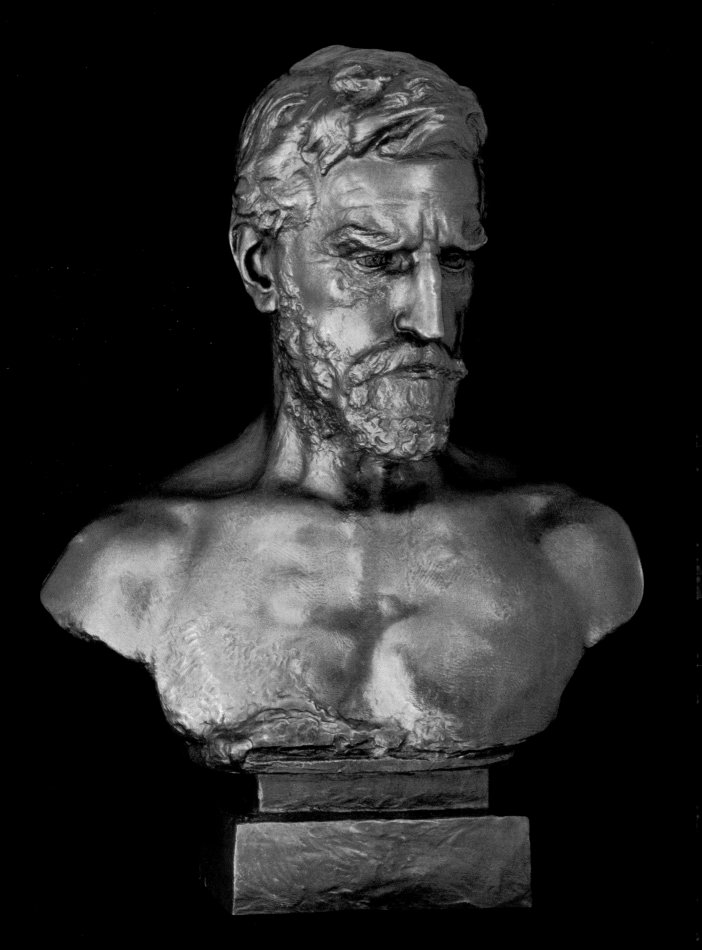

AMERICAN·SCULPTOR
OF·THE·GILDED·AGE

HENRY J. DUFFY

1. James Earle Fraser (1876–1953), *Augustus Saint-Gaudens,* 1905–26. Bronze, 1979, 32 × 23 × 16 inches. Saint-Gaudens National Historic Site, Cornish, N.H. (SAGA no. 7463). Gift through the Trustees of the Saint-Gaudens Memorial by Richard Wunder and Maurice Kawashima, 1998.

AUGUSTUS SAINT-GAUDENS (1848–1907) stands apart in nineteenth-century American sculpture as an artist who created his own style, one that revitalized American sculpture with a new spirit inspired by classical tradition.[1] Often compared to the great artists of the Italian Renaissance—indeed, he has been called the "American Michelangelo"[2]—Saint-Gaudens invigorated American sculpture and raised it to new heights in the late nineteenth century. In his Civil War monuments, particularly the *Shaw Memorial* (see pages 58–63 and 120) and the *Sherman Monument* (see pages 6–7 and 70–73), he created an art of direct, simple expression, free of the storytelling so common in his generation of artists. His portrait reliefs, done in low, almost painterly style, are the epitome of the type.[3] In contrast to practitioners of narrative or genre art, which developed in painting in the second half of the nineteenth century, Saint-Gaudens allowed the subject and the material to speak directly,[4] and in this he was an early proponent of modernism. Saint-Gaudens is important as both an artist and a strong force in the development of America's cultural life. As a teacher and activist, he played a prominent role in shaping the country's understanding of the art of sculpture.

Saint-Gaudens was recognized early by his contemporaries as an artist of merit,[5] and perceptive critics noted the distinctiveness of his art from earlier American work. The art of sculpture was just coming into its own in late-nineteenth-century America, introduced to the public by the classically inspired marble works of Hiram Powers (1805–73) and Erastus Palmer (1817–1904) and the emerging American themes of J. Q. A. Ward (1830–1910). These early works were created largely for public spaces or a select number of wealthy homes. For most Americans, sculpture was not perceived as an integral part of everyday life, as paintings often were. The evocative storytelling of genre and landscape painting, so popular during the Gilded Age, appealed easily to an audience largely untrained in the appreciation of

art. However, sculpture, partly because of its size, was more difficult to comprehend. Working to create programs and institutions that became the basis for the modern study and practice of sculpture, Saint-Gaudens and contemporaries such as Daniel Chester French (1850–1931) and Frederick MacMonnies (1863–1937) changed these perceptions.

The acceptance of and need for sculpture in the United States arose in conjunction with the country's growth after the Civil War (1861–65). Numerous monuments were commissioned to commemorate the national crisis; in addition, sculpture, in tandem with architecture, was used to evoke the country's new financial and economic strength. During the Gilded Age—so named by Mark Twain, who with his usual caustic humor captured in this description both the glory and ostentation of the great economic heyday that followed the war—the need for public and private sculpture increased. Art, both public and private, responded in style and material to the change in American life.

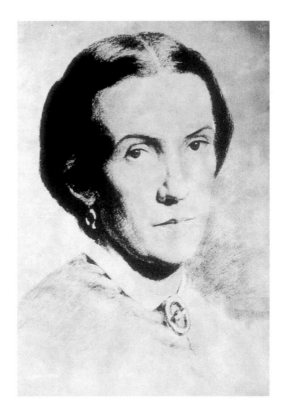

Mary McGuiness Saint-Gaudens, 1867. Pencil drawing. This drawing was destroyed in a fire in 1904.

Saint-Gaudens developed his art through hard work and dedication. His background—he was the son of hard-working immigrants who came to America in search of opportunity—was similar to that of many others in nineteenth-century New York City. Born in Dublin, Ireland, to a French father and an Irish mother, he emigrated with his family to New York when he was six months old. His father, Bernard, was a shoemaker whose approach to shoe making fit well with the nineteenth-century drive for innovation: he experimented with different designs and advertised his wares in a way that went right to the heart of the American need.[6] Contemporary photographs of the Saint-Gaudens house in New York reveal the father's strong marketing skill: advertising that targeted the upper echelon of New York society. The artist's mother, Mary McGuiness, was the heart of the family, holding together the business and allowing her husband and sons the freedom to dream big dreams in the new land of opportunity. Saint-Gaudens, in his *Reminiscences* (1913), credits his parents, especially his mother, for giving him the confidence to pursue a career that many first-generation Americans would not have considered.[7]

Saint-Gaudens began his career in art in 1861, at the age of thirteen, when he was apprenticed to the cameo cutter Louis Avet. After three years he left to work for Jules LeBrethon, another cameo cutter. Saint-Gaudens clearly

showed an early interest in art rather than trade, attending night classes at the Cooper Union in 1864 and day classes with Daniel Huntington (1816–1906), Emmanuel Leutze (1816–68), Launt Thompson (1833–94) and J. Q. A. Ward at the National Academy of Design in 1866. The following year his parents sacrificed their savings to send Augustus to Paris for further study in the arts. There his father's French heritage helped him gain admission to the École des Beaux-Arts. Perhaps as a way of thanking them, Saint-Gaudens created a beautiful pencil drawing of his mother and his first important bronze bust—of his father—before leaving for France in 1867.

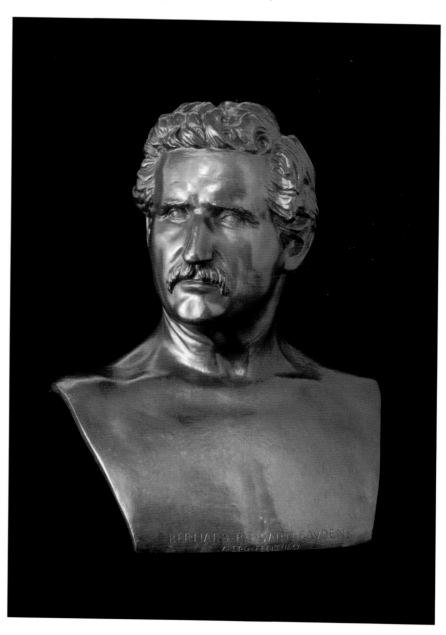

2. *Bernard P. E. Saint-Gaudens,* 1867. Bronze, 1867, 15 × 12¾ × 7¾ inches. Saint-Gaudens National Historic Site, Cornish, N.H. (SAGA no. 883).

Although Saint-Gaudens began his study of art in the United States, even American critics realized that his mature style was strongly influenced by his training in France from 1867 to 1875. In the 1860s and early 1870s American critics wrote often of the conflict between American and European art, and Saint-Gaudens himself admitted that he initially believed that only in France could an artist achieve any kind of training. This view was not altogether unjustified. The arts community was just beginning to coalesce in pre–Civil War America. New York City was not quite the center of culture it became after the war, but there nonetheless the young Saint-Gaudens had access to galleries and art schools.[8] One was right next door: the National Academy of Design on Twenty-third Street abutted the Saint-Gaudens house. At this time in America there was a general shift in taste from primarily German and English art to French and later other European art. However, when Saint-Gaudens launched his career on his return from Europe in 1875, the art scene in America had become quite exciting. Initially Saint-Gaudens followed public taste but later changed as he formulated his own vision; public taste, meanwhile, became more sophisticated.

18

When Saint-Gaudens arrived in Paris in 1867, the city was vibrant with the emerging culture of the Second Empire, and a large number of public buildings, all requiring decoration, were being constructed. The young man immersed himself in the art world of Paris and later Rome with a concentrated energy. What courses he took is unknown, as is whether the new philosophy of Positivism taught at the École by Hippolyte Taine (1828–93), author of *Philosophie de l'art* (1865), held any interest for him. What Saint-Gaudens did gain from his experience, however, was a clear understanding of traditional art and the immediacy

3. *Fanny Smith Whittlesey,* 1870. Pencil, 12 × 10 inches. Saint-Gaudens National Historic Site, Cornish, N.H. (SAGA no. 1552). Gift of Francis W. A. Hawley, 1971. This is one of the few surviving drawings by Saint-Gaudens.

Hiking trip to Naples, 1871—from left to right, George Dubois, Augustus Saint-Gaudens, and Ernest Mayor. Saint-Gaudens National Historic Site, Cornish, N.H.

of the realism practiced by French artists from Jean-Léon Gérôme (1824–1904) to the sculptors who would become his friends: Paul Bion (1845–97), Antonin Mercié (1845–1916), and Paul Dubois (1829–1905). These artists were at the forefront of revitalizing French art, adopting a fresher, bolder approach to expression and pose in sculpture and allowing the material—bronze or marble or plaster—to speak for itself.

When Saint-Gaudens began his career, he was one of only three American sculptors to be fully grounded in this bolder approach to art. It carried over into his oeuvre, and he himself passed it on in his own teaching at the Art Students League and in his various studios.[9] He was innovative but not revolutionary. In Paris he was interested primarily in the art of the establishment, and he approached his later acquaintance with Auguste Rodin (1840–1917) warily—with respect but not complete acceptance of the direction in which the Frenchman was moving the art of sculpture.[10] Rodin's early pieces were much admired, in part for the works' closeness to the viewer, and Saint-Gaudens sometimes adopted this technique, placing a number of his pieces low to the ground. However, he accepted impressionism less easily. He disliked what he saw as a lack of internal structure in the paintings of Pierre-Auguste Renoir (1841–1919), and Rodin's *Balzac* (1893) was beyond his understanding.

Nonetheless, what Saint-Gaudens found in Paris in 1867 was a greater appreciation and acceptance of sculpture as an art form than in his own country.[11] In America sculpture was generally treated either as household decoration or as a work of high moral tenor meant to instruct the audience. In the 1860s American artists still tended to look toward Europe for instruction and inspiration. Saint-Gaudens initially followed this process, but gradually—around 1900—he realized that American culture had changed. Although he did not acknowledge his own role in effecting that change, others did.

Lorado Taft (1860–1936), a sculptor and critic, outlined this shift in taste in his book *The History of American Art* (1917). In particular his chapter on the origins of sculpture gives a picture of the medium's place in American culture as seen by its practitioners and by Saint-Gaudens's contemporaries.[12]

In America the greater acceptance and understanding of art generally were tied to two factors: democracy and commercial independence. During the nineteenth century the public identity of America as a unified nation—rather than a collection of immigrants—was shaped to a large measure through the use of art. In painting the dominant theme was genre; the overwhelming majority of paintings in American galleries and collections fit this category. Even if the figures in the paintings were clothed in historical or European dress, the message was clearly one of moral decency as the basis for a person's or a nation's actions. This was probably inspired by America's rapid economic and commercial growth, strong before the Civil War but unstoppable in the decades afterwards. An increase in commercialism and the rise of a middle class—and middle-class values—was occurring in many countries throughout the world, but in America the trend was tempered by a unique kind of ethical responsibility. In America enjoyment of life had to be explained and justified in a way that bemused Europeans.

There was a disconnect, however, between critics and collectors and, to a degree, artists as well. Critics worried more about such issues as provincialism and justification for spending money on public monuments and other works of art. Because sculpture is larger and thus has a greater public impact, Saint-Gaudens and other sculptors became involved in the debate.

Saint-Gaudens became a vital player in this major shift in American artistic taste as European influence gradually began to be replaced by a more "homegrown" imagery and sentiment. In his role as a teacher, as a creator of important public monuments, and as an organizer of many of the main art expositions, Saint-Gaudens exercised a clear influence. It is interesting that the shift in taste came from artists and collectors, not so much from critics. Writers remained fixed on the concern for competition and were most fearful of provincialism. Artists such as Saint-Gaudens and the patrons who supported advancing artists and styles were ahead of the critics in their cosmopolitan world view.[13]

4. *John C. Calhoun,* ca. 1875–80. Marble, 22 × 14⅛ × 10⅝ inches, pedestal 5 inches high. Saint-Gaudens National Historic Site, Cornish, N.H. (SAGA no. 896). Gift of Effingham Evarts, 1962.

20

The state of American art at the time Saint-Gaudens first traveled to Europe is summarized in the article "The Extent of Art Knowledge: What Constitutes an Artist," which appeared in the May 24, 1874, issue of the *New York Times*.

America is almost without art, and nearly everything is to be created, and a great responsibility is put upon the artists now coming forward. It is their duty, as it is that of the true critic who has informed himself by study, to see to it that the monuments which are to be raised are models of good taste, so that they may serve as examples for all that shall succeed, and helps for the instruction of those who have not opportunity to learn in the great school always open in the Old World. We may doubt, and we may scold as much as we please, but in the future we are to have a great art blossoming and fruit ripening, if any dependence is to be put upon the promising buds with which our tree is now covered. . . . The whole nation will contribute to its nourishment. But to state the truth without figure, our painters and sculptors must study and work hard. . . . The method of art is toilsome and slow, and the lack of repose and patience in the American character ill fits it to submit to the hard discipline of the many years of study needed to lay a solid foundation of knowledge.

Saint-Gaudens in Paris, 1878. Saint-Gaudens National Historic Site, Cornish, N.H.

In 1867, when Saint-Gaudens left for France, the art world of New York City and America was still dominated by portrait painting, nationalistic scenes of the Hudson River School, and the beginnings of European-inspired genre.[14] In 1875, when he returned to New York City, artists and critics were engaged in a spirited debate about the relative merits of European and American training. The young sculptor came back with a thorough training from the École des Beaux-Arts in Paris and from his own work in Rome, where he had traveled in 1870, at the outbreak of the Franco-Prussian War.

The moment of return had a strong impact on Saint-Gaudens's later career. He found studio space in the German Savings Bank Building with a friend he had met in Europe, the painter-designer and diplomat David Maitland Armstrong (1836–1918).[15] Armstrong had brought Saint-Gaudens some notoriety in Europe by including him as a member of the jury to select American art for the Paris Exposition of 1878. Their radical approach to hanging

art works in the exhibition made them both friends and enemies, as the *New York Times* explained:

These young persons have struck terror to the heart of the American colony by judging pictures on the ground of artistic merit displayed in them. . . . Carried away by their mistaken enthusiasm for pure art, they have rejected pictures of great size, which show, almost as faithfully as a colored photograph, miles and miles of our unequaled Western landscape. . . . They have made the pitiable mistake of supposing the size of, and length of time occupied in the painting of, a picture has little to do with its artistic merit. On the other hand it may be urged that an expurgated show of American art is a novel and refreshing thing, which cannot fail to impress well those Europeans whose good opinion is of value.[16]

The story reveals the new modernism of the artists around Saint-Gaudens.[17] Although tongue in cheek, the article points out a difference between the more democratic American point of view and the old traditions of Europe. Armstrong recalled that young artists whose work was deemed better than their well-known colleagues were given pride of place, an approach popular with the beneficiaries but surprising to those who expected special treatment because of their social or political position.

Saint-Gaudens working on the portrait relief of Mrs. Grover Cleveland at the studio of Helena De Kay Gilder in Marion, Massachusetts, 1887.

Saint-Gaudens's subsequent meeting and friendships with the architects Stanford White (1853–1906) and Henry Hobson Richardson (1838–86) and the painter John La Farge (1835–1910) not only provided important artistic support but also set the direction of his future creation. All of these artists were part of a new breed of American artist: people who were familiar with the tradition of classical art but who were setting their sights on a style unique to America. All sought to clarify and simplify the art of the past, fusing European tradition with the simple moral tone preferred by Americans. What developed then was a cosmopolitan style. The friendship and close working relationship that developed between Saint-Gaudens and Stanford White, in particular, formed one of the most important artist teams in Gilded Age America, responsible for the monument to Admiral

23

Left: Saint-Gaudens (far right) during his first summer at Aspet in Cornish, in 1887, with (from left to right) his brother Louis; Frederick MacMonnies, his assistant; his son, Homer; and his wife. Saint-Gaudens National Historic Site, Cornish, N.H.

Below: Aspet and Mt. Ascutney today.

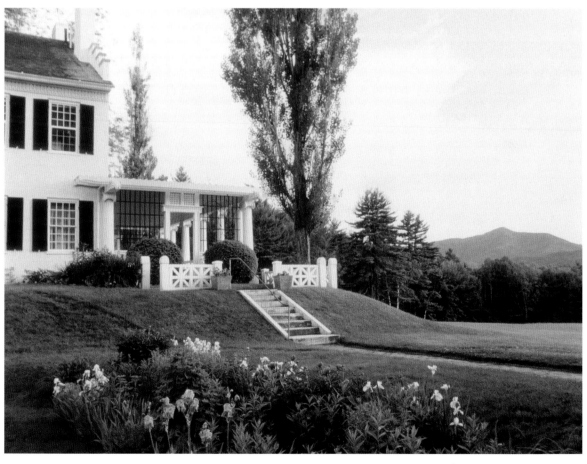

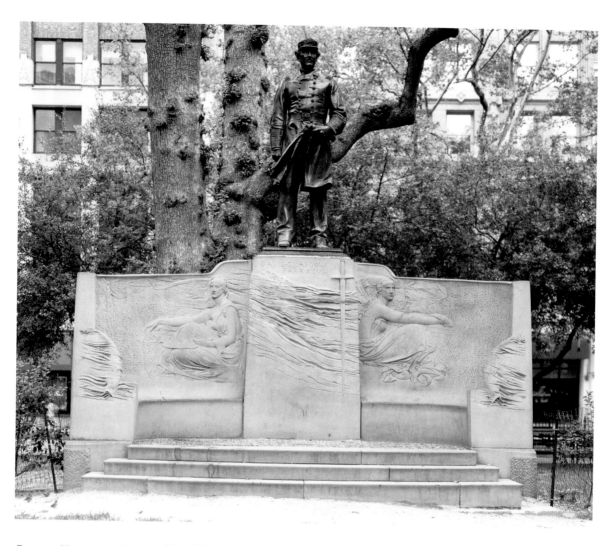

Farragut Monument, 1881.
Madison Square Park,
New York.

David Farragut (see above and pages 56–57), the *Diana* (see pages 80–83), and *The Puritan* (see pages 74–75 and 128), among others.

Two of the earliest examples of Saint-Gaudens's collaboration with other artists to express this new ideal were the frescos in Trinity Church (1877), Boston, and the reredos for St. Thomas Church (1877) in New York City. In both, John La Farge brought Saint-Gaudens into the aesthetic sentiments of late-nineteenth-century modernism, introducing him to a style based on a wide-ranging knowledge of European, Asian, and American art. Not only were these commissions "modern" in the artistic sense; they also expressed the prevailing nineteenth-century desire to make religious art acceptable to an American sensibility that was largely puritanical, Protestant, and anti-Catholic. In these and other works on his return, Saint-Gaudens was brought into the debate of European versus American art and thus found himself in the vanguard of the new approach to art forged by La Farge, White, and others.

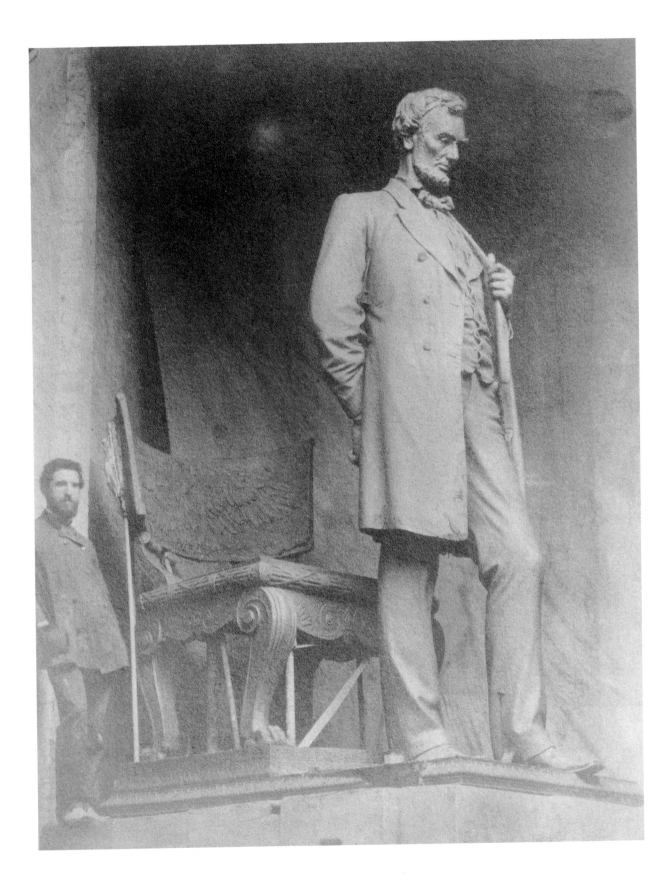

SIMPLICITY OF SUBJECT, REALISM OF FORM, STRENGTH OF EMOTION

The importance of the issue of the European training of American artists is difficult to understand today, but in nineteenth-century America the absorption of various immigrant cultures was still sufficiently new as to be troubling to some critics. Because so many Americans were first or second generation, their Old World values and beliefs were still strong. Thus, the issue of artists such as Saint-Gaudens being trained in Europe seemed to some critics to be a nationalistic question: Was the artist more loyal to the United States or his European country of origin? Further, would the ideas learned overseas be destructive to the cohesiveness of the young republic, still reeling from the effects of the Civil War?

As late as November 4, 1883, a critic in the *New York Times* wondered whether it was better to have

Saint-Gaudens and the *Standing Lincoln,* 1887. Saint-Gaudens National Historic Site, Cornish, N.H.

the incomplete groping after American subjects, using a technique conspicuous for absence of smartness in drawing and richness in coloring shown by the Americans, or the superficial imitation of foreign schools shown by the European Yankees? Certainly the American unmixed rests professionally on a sounder basis than the American affected by Europe. He cannot exist at all without a certain amount of support from the public, he must have some home patronage from actual buyers. The foreign American, on the other hand, is much more likely to be wholly or partially supported by remittances from the United States. When he sells here it is generally to a chance patron. The native artist may be less fastidious, less wide in culture; but after all he does honester [*sic*] work and stands more chance in the long run to become a national artist. The other paints in a medium of ideas that do not, and perhaps never will, penetrate the ranks of his countrymen, and runs the risk of getting every year further and further from sympathy with them. To become a real success abroad it would be necessary to overcome the prejudice against foreign work and the weight of national vanity, not to speak of the superhuman attempt to absorb thoroughly the foreign ideas that begin with childhood and are as natural to the real foreigner as breathing.

Whether he was aware of it or not, Saint-Gaudens played a part in this debate. By joining with the young, innovative artists such as Armstrong, La Farge, and others, he was more modern than he may have known. The relative safety of the Hudson River School painters or the clearly defined works of such sculptors as William Reinhart (1825–74) or Hiram Powers was being

challenged by this young generation, which sought to draw out the inner workings of the individual as opposed to nationalistic or moralistic imagery of an artistic ideal.[18] In this Saint-Gaudens sided with the most important art patrons—people like Edwin Morgan, governor of New York, and the Vanderbilts (see pages 30–31), who did not follow the advice of critics. These patrons bought European art and supported sculptors such as Saint-Gaudens and painters such as George Inness (1854–1926), artists who were simplifying the surface of their figures and concentrating on expression. Saint-Gaudens's gift was his subtle balance between surface realism and psychic energy unmatched by any of his contemporaries.

The artist-critic Lorado Taft, who knew Saint-Gaudens, saw him as the beacon for the development of a true American style in sculpture. Taft understood America's initial unease with sculpture. Pioneer and colonial culture did not take quickly to its larger scale. America's Puritan origins, while instrumental to the development of national character, seemed to Taft an obstacle to the rise of all creative arts. He probably was accurate in his assessment that the earliest forays—commissioning copies of ancient busts—was an attempt to copy the appearance of culture, often without a complete understanding of the reason for doing so. Such works were usually placed in the libraries of private homes, indicating a link between the young American republic and the ancient cultures that gave it ideological birth. For Taft the big change came with Saint-Gaudens and his introduction of French ideals into American art:

With the advent of Saint Gaudens[19] there came a notable change in the spirit of American Sculpture, while the rapid transformation of its technic [sic] was no less marked and significant. Though we owe this change largely to Paris, the result has not been French sculpture. Paris has vitalized the dormant tastes and energies of America—that is all. A pronounced and helpful feature of the new order is the fact that as a rule the Parisian-trained sculptors do not remain abroad; they return to live with their own people and, like their French masters, they delight in teaching. The influence

28

5. *Amor Caritas, Monumental,* 1885–99. Plaster, 103⅞ × 50 × 11¹³⁄₁₆ inches. Saint-Gaudens National Historic Site, Cornish, N.H. (SAGA no. 910). Gift of Pittsburgh Museum of Art, Carnegie Institute, 1948.

Saint-Gaudens in his Paris studio with *Amor Caritas* variant, 1898. Private collection.

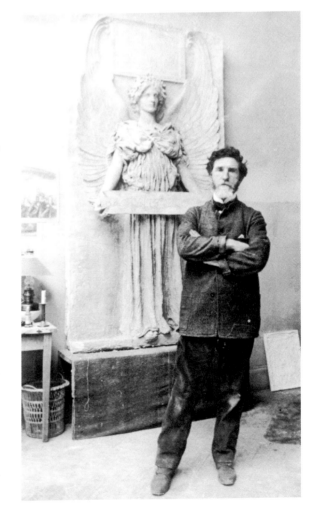

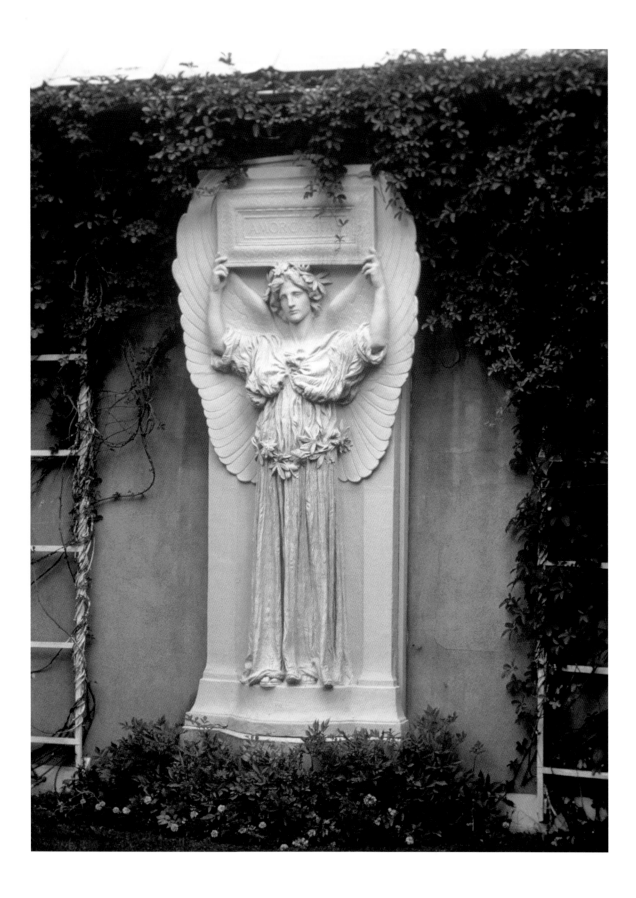

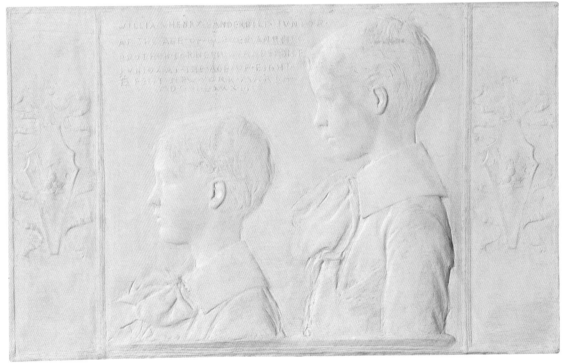

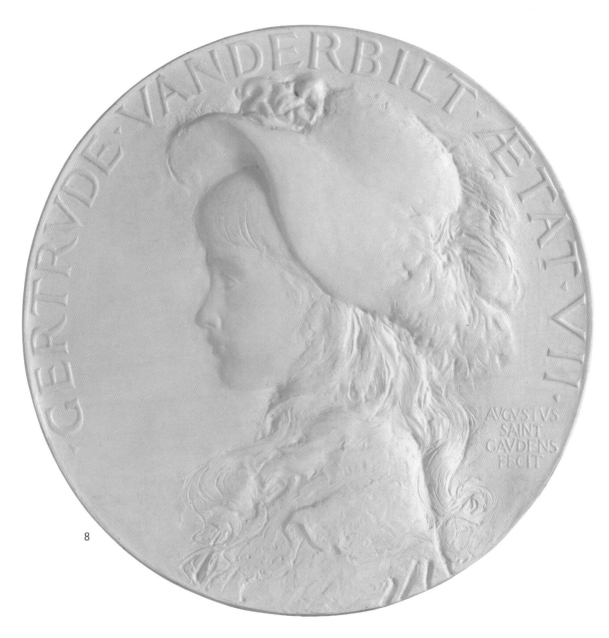

8

6. *Cornelius Vanderbilt I,* 1882. Plaster, 16½ × 18½ inches. Saint-Gaudens National Historic Site, Cornish, N.H. (SAGA no. 1218).

7. *William Henry Vanderbilt II and Cornelius Vanderbilt III,* 1882. Plaster, 16½ × 26¾ inches. Saint-Gaudens National Historic Site, Cornish, N.H. (SAGA no. 53).

8. *Gertrude Vanderbilt,* 1882. Plaster (reworked from the original model), 1899, 14¾ inches diameter. Saint-Gaudens National Historic Site, Cornish, N.H. (SAGA no. 56).

of such a man as Saint Gaudens . . . becomes incalculable when multiplied through the pupils whom he has brought up to share his labors and his triumphs.[20]

Whether in French art or in his own, Saint-Gaudens was drawn to simplicity of subject, a "realism" of forms, and an underlying effect of true emotional impact. His works engaged the audience in a more immediate way than any other American sculpture at the time.[21] The artists who gathered around Saint-Gaudens—John La Farge, Francis Davis Millet (1846–1912) (below), Dennis Miller Bunker (1861–90), George DeForest Brush (1855–1941), Thomas Dewing (1851–1938), Willard Metcalf (1858–1925), and John Twachtman (1853–1902)—were a new breed of realists, artists who focused on the inherent spirit of the landscape or the people around them. Their paintings were also direct, clear accounts—almost recordings—of their surroundings. Yet each had an underlying spirit that made their work more than a simple snapshot.[22]

While in Europe, Saint-Gaudens also met European-Americans such as John Singer Sargent (1856–1925) (see page 105) and James McNeill Whistler (1834–1903) (see pages 4 and 43). For Saint-Gaudens, a man set on finding the core of his subject, his friendship with Whistler, like his strong friendship with Robert Louis Stevenson (1850–94) (see pages 106–7), might seem unexpected. But Saint-Gaudens was both a dreamer and a realist. He appreciated the spiritual side of life, if not the attendant philosophies or talk.

During his studies Saint-Gaudens was fortunate to meet in Europe artists who were also pushing out away from the old established art academies. His break from the American Academy and his support in forming the Society of American Artists in 1877 were indicative of his interest in dispensing with the political structure of the old art society. In Rome, where he went to escape the Franco-Prussian War, it was the direct appeal of Renaissance art that caught his attention. While similar to what he was seeing in French art, the clarity of the Renaissance art and the sense of modernism that it brought to the academicism of classical art were exciting to him.

32

Opposite: Augustus Saint-Gaudens, ca. 1890s. Saint-Gaudens National Historic Site, Cornish, N.H.

9. *Francis Davis Millet,* 1879. Bronze, 10½ × 6½ inches. Saint-Gaudens National Historic Site, Cornish, N.H. (SAGA no. 873).

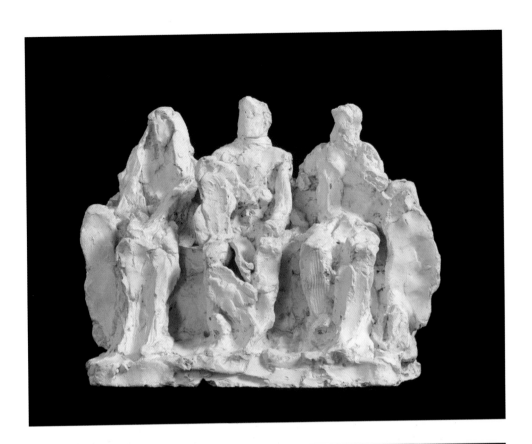

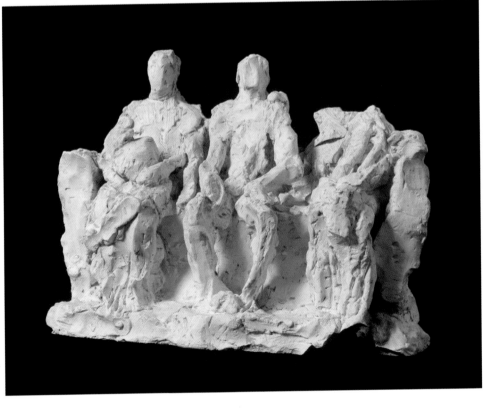

10. Boston Public Library Group, Preliminary Plaster Study, 1892–1907. Plaster, 8 × 11 inches. Saint-Gaudens National Historic Site, Cornish, N.H. (SAGA no. 69a)

The place of sculpture in American art was not really appreciated by the critics until later in the nineteenth century. While Saint-Gaudens reveled in the great sculptural works of Europe—in addition to Paris and Rome, he visited Pompeii and Tuscany—American sculpture was generally confined to decoration. An 1889 exhibition of bronze animal figures by Antoine-Louis Barye (1795–1875) in New York City, an exhibit for which Saint-Gaudens was one of the organizers, introduced a dramatic style and sparked public debate about why sculpture had not taken hold of the public imagination in America as it had in Europe.

The article "The Bronzes of Barye: Their Infinite Variety and Importance to American Sculpture," which appeared in the *New York Times* on November 16, 1889, declared:

It is plain that sculpture is on an entirely false basis with us. It is an exotic. It does not enter into our daily lives, nor belong to the list of luxurious necessities like water colors and oils. Yet so far as monumental art is concerned, that we are only too ready to demand from our sculptors. But our own taste and their talents have not been shaped so as to produce good sculpture save here and there. We do not ask our sculptors for bas-reliefs, chimney pieces, portraits, ornaments for our houses, statuettes of all kinds. Yet the few workmen who produce figures and groups belonging to this branch of art are sufficiently successful to warrant us in believing that there is a great public demand for such sculpture which needs only to be hit. But they are generally artists of feeble imagination and inadequate technique, while the highly-trained sculptors reserve their strength for efforts on a higher plane of art. What we now need is a demand for sculpture of the finest sort for the home and a supply of sculptors who will follow Barye in the daring and originality of his works.

11. Boston Public Library Group, Preliminary Plaster Study, 1892–1907. Plaster, 8 × 9½ inches. Saint-Gaudens National Historic Site, Cornish, N.H. (SAGA no. 69b)

Lorado Taft would have agreed with the tone of this article, noting the pivotal role that Saint-Gaudens played in forming a true national style, but saw that as only the first step. The audience simply did not yet exist; ". . . we know what we like, but we don't know what that means."[23] Taft saw a lack of "passion" for art. The French had it, but Americans did not. The difference then between Saint-Gaudens and an artist like J. Q. A. Ward, while also very skilled, is that Ward's art is linear, precise, focusing on details.[24]

35

For Taft, Saint-Gaudens was "artless," a theme continued by other writers to the present day. The art historian Chandler Rathfon Post equated this subtlety of expression with the basic American need for order:

... perhaps the thing that strikes one as most American is Saint-Gaudens's sobriety. [His figures] have what we like to think is an American staidness and dignity. ... He sacrificed the wonderful ebullition of French sculpture and cultivated the emotional restraint proverbially ascribed to New England and to some degree typical of the whole nation; but he possessed the incomparable gift of pouring such life into his most static figures that even the best of what had gone before in American sculpture seems torpid by contrast.

According to Post, Saint-Gaudens's "poise" and "sedate poetry" make his realism "always bridled."[25]

This point, which most modern critics have missed, was key to a nineteenth-century understanding of Saint-Gaudens's work. Critics today tend to think that the artists of the last century sought realism as an end in itself, but they did not. Simply making something look like what it represented was not enough. As one critic for the *New York Times* described it, "realism is only a step to something else."[26] Post went on to describe "many other essentially American qualities, such as his hostility to any affectations or meretricious appeals and his respect for American conventions in an almost absolute avoidance of the nude." Other qualities included "a simple nobility and hardihood, the rough naturalness that belongs to a young nation, the curious fusion of reticence and frankness."[27]

Taft, in describing Olin Warner's sculpture *The Garrison,* also expressed what he liked about Saint-Gaudens. "It has something of the same quality as Mr. Saint Gaudens's 'Farragut', a repose which is deceptive, and which goes far to enhance the effect of internal activity. Within the quiet, unaccentuated contours of this composition is a slumbering fire, a tension betrayed only by the clutch of the hands and the vigorous turn of the head." The piece reflects "individuality"; it is "alive" and "aflame with energy and emotion, not a single stroke has carried it to excess." *The Garrison* is "a pent-up volcano."[28]

For Taft and others, Saint-Gaudens epitomized the spirit of America in the late nineteenth century. His rugged appearance and the confident sense of honesty, clarity, and simple truth exemplified in his sculpture and in his own public image were central to nineteenth-century cultural belief and to the newfound awareness in America of the nation's changed position in the world.

Saint-Gaudens himself points to the embodiment of character as key in sculpture. In a letter written on February 21, 1881, to his friend the editor Richard Watson Gilder, the sculptor wrote: "There seems to be a current opinion that a thing to be good must be unfinished. The finish or lack of finish has nothing to do in the classification of a work as good or bad—its character, regardless of that, is the thing. For sculpture is simply one of the means of expressing oneself, according to the temperament of the worker."[29]

One of the young artists Saint-Gaudens met in the 1870s was the painter Will Low (1853–1932). Low was important to Saint-Gaudens in many ways, assisting with the completion of the St. Thomas reredos and the founding of the Society of American Artists. In his memoirs, *A Chronicle of Friendships 1873–1900*, published in 1908, he recalled a story that summarized Saint-Gaudens's skill as an artist and the esteem in which he was held by his European colleagues. Low and a French artist stood in front of Saint-Gaudens's *Amor Caritas* (see pages 29 and 84–87) in Paris, a work that had been criticized as "not sculpture." The Frenchman replied:

Saint-Gaudens (third from left) and others— including James Earle Fraser, Henry Hering, and Elsie Ward— working on the plaster of the *Sherman Monument* in the interior of the Large Studio at Aspet, 1901. Saint-Gaudens National Historic Site, Cornish, N.H.

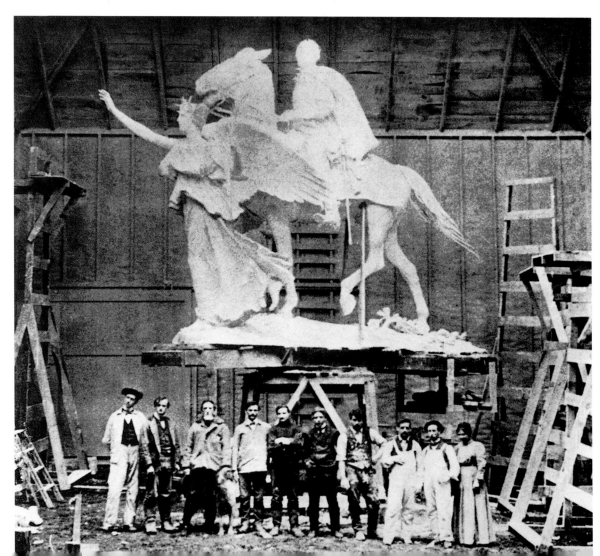

Here is a gallery filled with modern sculpture, some of it living, and some of it dead. The greater part shows technical ability of a high order, but how infrequently the quality of expression is of equal import, and how few that we cannot trace back to some previous work. Here is a work pregnant with meaning; of a symbolism that appeals to all; that is novel and personal in its presentation; whose *facture* we hardly consider, so appropriate are the technical methods suited to its theme. Our friend denies that it is sculpture, it may be something better; it is individual, it is beautiful, beyond dispute it is Art.[30]

Saint-Gaudens did not write much about his artistic theories, deliberately avoiding any such pontificating on a subject that was, for him, more inner-directed. He spoke about the subject briefly in his *Reminiscences*.

I thought that art seemed to be the concentration of the *experience* and *sensations* of life in painting, literature, sculpture and particularly acting, which accounts for the desire in artists to have realism. However there is still the feeling of the lack of something in the simple representation of some indifferent action. The imagination must be able to bring up the scenes, incidents, that impress us in life, condense them, and the truer they are to nature the better the imagination may condemn that which has impressed us beautifully as well as the strong or characteristic or ugly.[3]

38

West and south elevation of the Large Studio (Studio of the Caryatids) at Aspet, 1905. Saint-Gaudens National Historic Site, Cornish, N.H. Gift of Mrs. William Stillman, 1993.

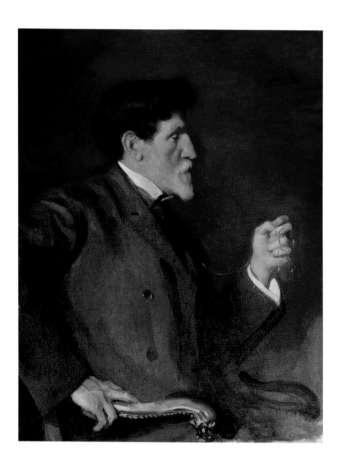

12. Ellen Emmet Rand (1876–1941), *Augustus Saint-Gaudens,* ca. 1904. Oil on canvas, 38⅞ × 30 inches. The Metropolitan Museum of Art, Rogers Fund, 1908 (08.129).

Saint-Gaudens established himself as a teacher early in his career. He taught in a direct, participatory way but allowed students to find their own answers to problems as well. Several accounts of his teaching exist, and all emphasize the importance he placed on seriousness of purpose, details of anatomy and structure, and what he called "fragrance"—the unspoken quality that separated good art from bad. Although he himself had been taught primarily in Europe, his teaching approach was American in the sense that he treated all students equally.[32] Whether young or old, men or women, they all were accorded the same combination of gruffness and tenderness.[33] He was clearly concerned with his pupils as individuals, not as a faceless crowd. He gave what he received; to serious students he would devote whatever time and effort was needed, but to students who were not serious he gave little or no attention. A man with a wonderful sense of humor, Saint-Gaudens did not admit humor in the workplace. He urged his assistants to combat the stress of work through vigorous outdoor recreation, and at his studio in Cornish, New Hampshire, he installed a swimming tank, golf course, billiard table, weights, lawn bowls, and a large toboggan run. But this kind of pleasure had its own place.

The question of training occupied Saint-Gaudens's attention to a great degree. Initially convinced that America could not offer adequate training, Saint-Gaudens changed his mind by the end of his life. In 1905 he wrote to a young student:

The older I grow, the more and more I am convinced that as thorough and adequate training can be had here as abroad, that the work by the students here is equal to that produced by those in Europe, and that belief in this by the students will help greatly in their education. Of course Europe, with its wealth and glory of art, must be seen and imbibed sooner or later. That goes without saying. But I

39

believe, for the American, the best time for that is after he has had a sound academical foundation here. It is time to realize that the training here is excellent, and that we are constantly adding to the list of men of high achievement whose education has been at home. . . .[34]

What may not be adequately remembered is the impact Saint-Gaudens had on effecting the change he refers to in his letter. He was in a position to rewrite the story of art education in the United States, and he began with his own studio. His assistants operated in a traditional workshop system familiar since the Renaissance. They worked in a hierarchic pattern with the master, Saint-Gaudens, at the top. At the second level were fully trained sculptors, who still received advice from Saint-Gaudens. Below these were assistants in training, and beneath them a staff of specialists and general laborers. Here, however, Saint-Gaudens gave equal attention to all, and all were encouraged to reach their full potential as artists.[35]

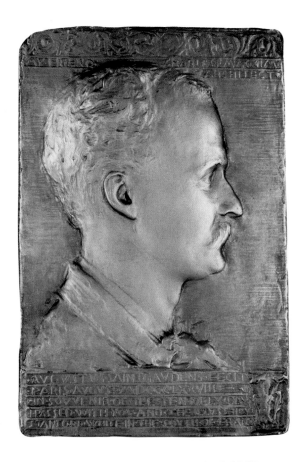

13. *Charles F. McKim,* 1878. Silvered bronze, 7½ × 5 inches. American Academy and Institute of Arts and Letters, New York.

Saint-Gaudens's teaching at the Art Students League in New York City, from 1888 to 1896, reached numerous younger sculptors, but his teaching did not end there. Through his participation in clubs, fairs, public exhibitions, and art societies, he reached out throughout the country. Several arts societies—the Society of American Artists, National Sculpture Society, and American Academy in Rome—were founded with his active participation.[36] He was involved with all the major exhibitions—including the World's Columbian Exposition, Barye Exhibition, and Exposition Universelle in Paris in 1878, 1889, and 1900—as a commissioner or major organizing force. In 1901 Saint-Gaudens, along with Charles F. McKim (see above and page 90), Daniel Burnham (1846–1912), and Frederick Law Olmsted Jr. (1870–1957), was named to the Senate Park Planning Commission for the District of Columbia by Senator James McMillan. Thus Saint-Gaudens played a role in setting the course for the nation's capital, retaining the spirit of Pierre Charles L'Enfant (1754–1825) and the grace and beauty of the city's central core.[37]

The process of founding the American Academy in Rome met a central goal of the late nineteenth century: to achieve lasting benefit through the use

Augustus Saint-Gaudens in Cornish in his later years, ca. 1905. Saint-Gaudens National Historic Site, Cornish, N.H.

of culture. The accomplishments of Saint-Gaudens, Stanford White, and others in his circle were furthered by the unique character of the time in which they lived. The great post–Civil War commercial families such as the Vanderbilts, Goulds, and others built individual fortunes but also felt an obligation to use their fortunes for public betterment. Parks, museums, and other public spaces were built. The art of Saint-Gaudens characterized the aspirations of these people in images of simple dignity and strength.

An American facility to train artists in the heart of classical Rome was a dream inspired by the World's Columbian Exposition in Chicago in 1893, which was intended, among other things, to exhibit America's power as a nation and as a culture to the rest of the world.[38] Spurred on by Charles McKim, architect and friend of Saint-Gaudens's, the idea arose out of a growing confidence in the United States that at last supplanted the long-standing fear of the country's cultural inferiority to Europe. The American Academy was organized to offer to American artists in Rome the same opportunity provided by the Villa Medici, which, however, was open only to French citizens. Saint-Gaudens was a strong force in the creation of this academy, as he had been in the development of the Society of American

Artists. He himself had been permitted entry into the École des Beaux-Arts in Paris, for which he was always grateful.

At the same time Saint-Gaudens's own ideas about European versus American art training were changing. In 1893 he still believed that Europe provided a better source of cultural awakening, but by 1905, when the American Academy was founded, he was writing of the importance of American artists staying in this country to learn about art. What changed in those twelve years was America's place in the world community. The constant fears of critics that the country was inferior culturally had begun to dissipate, and the triumph of the World's Columbian Exposition had shown to Europeans and Americans themselves how insignificant was the separation between the Old and the New World.

In Saint-Gaudens's art can be seen a reflection of the country's growth and maturity. The blend of classical structure and order with an easy modern sensibility was characteristic of the nineteenth century. Saint-Gaudens's teaching had gone far in bringing about a change in the public's acceptance of sculpture as a popular art medium. By the time of his death, sculptors were fully represented in art exhibitions and fairs. The collecting of sculpture by individuals, while still behind painting to a considerable degree, had grown as well. That sculpture could be more than decoration was becoming clearly understood. Most important, a new generation of men and women had entered the arts, encouraged by Saint-Gaudens and the societies and programs he had helped develop. His conscious effort to develop systems and procedures for equitable treatment of all artists is a contribution for which he has never been given adequate credit.

While Saint-Gaudens's legacy was thus a wide-reaching one, his own vision of sculpture would shift again in the public imagination. Soon after his death and particularly around the time of World War I, American culture

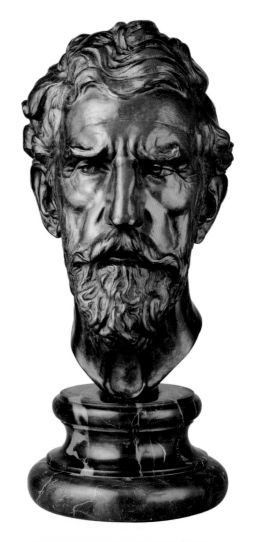

14. John Flanagan (1865–1952), *Augustus Saint-Gaudens,* 1905–24. Bronze, 1924, 16½ × 8 × 10 inches. The Metropolitan Museum of Art, Francis Lathrop Fund, 1933 (33.62).

15. *Whistler Memorial Sketch,* 1906–7. Plaster, 28 × 12⅝ inches. Saint-Gaudens National Historic Site, Cornish, N.H. (SAGA no. 1480).

changed dramatically. Saint-Gaudens's direct depiction of people and events lost some of its appeal as the fashion for abstraction of forms took the ascendency in art. Nonetheless, his students and the artists influenced by his training continued on into the twentieth century. Today Saint-Gaudens is once again recognized as a central figure in the art of the developing nation, bridging the gap between the nineteenth and the twentieth centuries and laying the groundwork for what was to come.

THE · CATALOGUE

JOHN H. DRYFHOUT

*Davida Johnson Clark,
First Study for the
Head of Diana,* 1886
(see page 77).

"A SCULPTOR'S WORK ENDURES so long it is next to a crime for him not to do everything in his power to produce a good result."[1] With that philosophy Augustus Saint-Gaudens went on to create a great variety of three-dimensional works beginning in his early years with cameos in stone and shell, mural paintings, stained glass, and mixed-media decorative panels that enhanced the architecture and interiors of some of the most magnificent mansions of his day. In his maturity he was a great portrait artist, creating during his thirty-year career more than one hundred sculptural portraits, more than eighty of which are in relief. Many of them form the basis of his monumental works, which can be described as an artistic synthesis of the ideal and the real. Public monuments, by their nature a full measure and representation of a sculptor's success, account for more than twenty of his separate commissions. To these must be added medals and the most renowned of his works in this medium: the U.S. 1907 gold coinage created for the nation. He introduced an affordable and accessible format to American sculpture, with reductions of some of his most popular statues and portrait reliefs. This made it possible for museums and individuals alike to include his work in their collections. Saint-Gaudens's reputation and the popularity of his work established him as the leading American sculptor of his time.

45

DECORATIVE OBJECTS

The great wealth garnered by the expansion of the economy after the Civil War led to a burgeoning of activity in creating great houses and art collections. Travel by train and ship and innovations in communication brought America closer to Europe and the Orient and provided Americans with a new awareness of culture and style. Saint-Gaudens's reputation was made at this time.

Already imbued with an interest in sculpture from his early life and study at the Cooper Union and the National Academy of Design in New York City, he was one of the first American sculptors to study in Paris. His immersion in the National Academy of Design as well as the École des Beaux-Arts was extraordinarily important in his personal training. After the outbreak of the Franco-Prussian War in 1870, he was forced to relocate and establish himself in a studio in Rome, putting him in touch with some of the wealthy American patrons who were buying art on trips abroad. Rome also provided an opportunity for Saint-Gaudens to become associated with sculptors like William Reinhart, who represented the previous generation of successful artists whose expatriate existence ensured access to the American community abroad.

Saint-Gaudens was a master carver of cameos, and this skill served him well, providing a steady income in New York City, Paris, and Rome. For the family of Joseph J. Stuart, an important New York banker, he made two sets of cameos depicting Stuart along with his wife, Anna Watson Stuart, and their children, Robert, Joseph, Margaret, and Anna. One set is of shell, set in gold and in the form of a bracelet, and includes a pair of earrings and a brooch (see page 49). A companion set (in a private collection) for Anna Watson Stuart is shown in her portrait by Daniel Huntington, Saint-Gaudens's teacher at the National Academy of Design; the painting is now in the Metropolitan Museum of Art.

16. *Ceres Panel,* Cornelius Vanderbilt II House, New York City, 1881–83. Mahogany, holly wood, bronze, ivory, mother-of-pearl, and marble; 62¾ × 25¼ inches. Saint-Gaudens National Historic Site, Cornish, N.H. (SAGA no. 2527).

47

Another cameo (opposite bottom right), no doubt completed during his sojourn in Rome, was carved by Saint-Gaudens for Abigail Williams of Salem, Massachusetts. Depicting Mary Queen of Scots, a favorite subject, it recalls the onyx brooch cameo of the same subject that Saint-Gaudens created for his fiancée, Augusta Homer of Boston, whom he met in Rome while she was studying and working as a painter there.

The shell cameo of George Washington (opposite bottom left) is representative of another favored historical subject. Based on the bust by Jean Antoine Houdon (1741–1828) and the Duvivier medal of 1789, the cameo was said to have been given by Saint-Gaudens to the German-born wood engraver John Karst (1836–1922), no doubt in exchange for a work done by Karst, who had a studio in New York City. Earlier Saint-Gaudens had given a set of cameos to the sculptor J. Q. A. Ward, who supported Saint-Gaudens's commission for the Admiral David Farragut monument in New York City in 1876. Saint-Gaudens developed a camaraderie with many of his fellow artists that led to such exchanges. On a number of occasions after 1877, he would exchange a relief portrait of a fellow artist for a painting by that artist.

Saint-Gaudens also produced small medallions for Tiffany and Company in 1875 to be used in the production of the great Bryant Vase (see pages 50–51). The four medallions surrounding the upper portion of the vase depict William Cullen Bryant (1794–1878), the American poet famed for his nature-centered poems such as "Thanatopsis," "To a Waterfowl," "Autumn Woods," and "The Yellow Violet." Bryant was also an editor and publisher of the *New York Evening Post*. The silver vase, of which this is a copy, was presented to Bryant at a great dinner in his honor on June 20, 1876, in New York City. The medallions, after the models by Saint-Gaudens, include scenes from the poet's life, such as father and son with a bust of Homer and the young Bryant contemplating nature. On the opposite side are Poetry and Nature, flanked by medallions representing Bryant as a journalist and as a translator of Homer. The overall design was by James H. Whitehouse of Tiffany and Company; the silver medallions were chased by Eugene J. Soligny.[2]

48

17. *Stuart Family Cameo Jewelry (Bracelet, Brooch, Earrings),* after 1861. Shell and gold; bracelet 1 × 1¼ (each cameo) × 8¾ inches, brooch 1¼ × 1⅜ inches, earrings 1 × ⅞ inches. Saint-Gaudens National Historic Site, Cornish, N.H. (SAGA nos. 6903, 6904, 6905). Gift of Mary B. Frost, 1993.

18. *George Washington Portrait Cameo,* ca. 1875. White on rose and beige shell, 2⅛ inches oval. Saint-Gaudens National Historic Site, Cornish, N.H. (SAGA no. 1536). Gift through purchase of the Trustees of the Saint-Gaudens Memorial, 1971.

19. *Mary Queen of Scots Cameo,* 1873. Onyx, 1⅝ inches diameter. Saint-Gaudens National Historic Site, Cornish, N.H. (SAGA no. 1539).

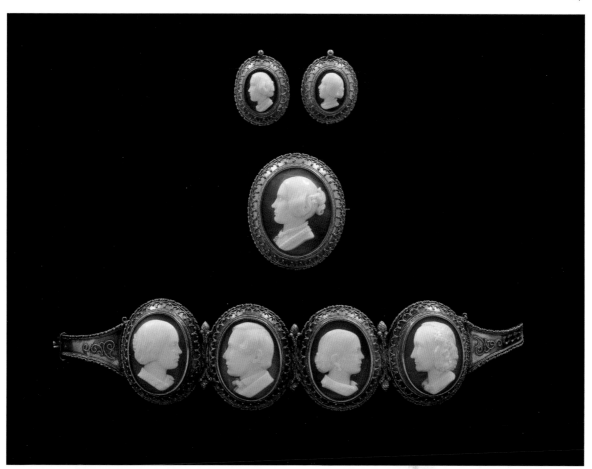

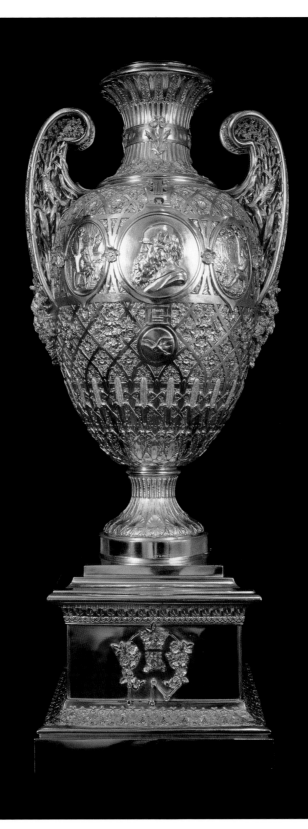

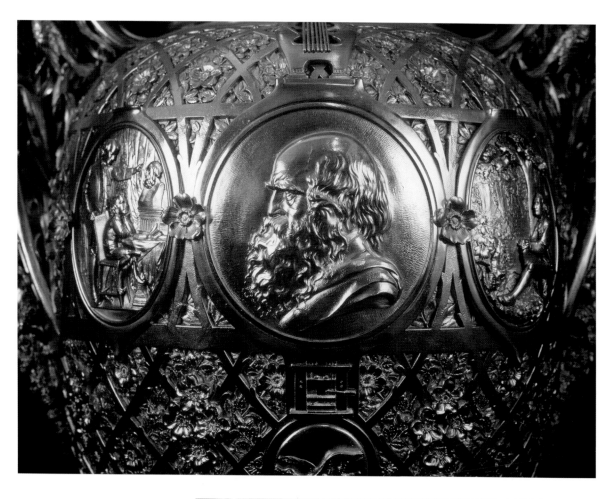

20. James Whitehouse, design; Eugene J. Soligny, chaser; Augustus Saint-Gaudens, medallions; *Bryant Vase;* 1875. Silverplated copper electrotype, 33 × 14 × 11¼ inches. Produced for Tiffany and Company, New York City. The Century Association, New York. Gift of Agnes Osgood (1905.1).

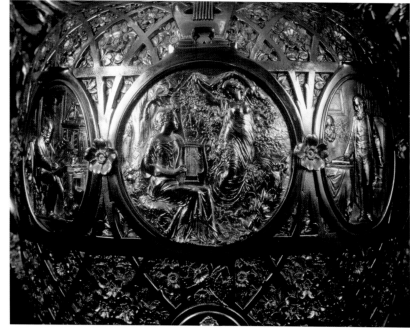

Saint-Gaudens was also engaged in other work for the firm, including sculptural elements for a pair of six-light candelabra, commissioned by the *New York Herald* publisher James Gordon Bennett, to commemorate a yacht race outside New York Harbor on October 26, 1875. The candelabra were exhibited by Tiffany in the Philadelphia Centennial Exposition in 1876 as well as at the Paris Exposition of 1878. A second pair was made for Mary Jane Morgan and was sold at auction (with the added attribution to Saint-Gaudens) in New York City in 1886, purchased by Mrs. George W. Quintard, Morgan's stepdaughter. (Both sets remain unlocated.)

Two very large commissions came to Saint-Gaudens between 1880 and 1881, both for interior decorations of two great houses in New York City. One—the house built for Cornelius Vanderbilt II, grandson of the founder of the railroad and steamship transportation empire and located on Fifth Avenue at Fifty-seventh Street—was created in collaboration with the painter John La Farge and the architect George B. Post (1837–1913). The other, built for the railroad and electricity promoter and financier Henry Villard and located on Madison Avenue between Fiftieth and Fifty-first Streets, was a block-long complex of three separate townhouses. The complex was inspired by two Italian Renaissance palaces, the Cancelleria and Farnese, both in Rome, and designed by the architecture firm McKim, Mead and White.

One of the few surviving panels from the now-demolished Vanderbilt house is a testament to the excellence of materials and design that marked the richness of La Farge's conception as well as the opulence of the interiors of these great American Renaissance houses. Saint-Gaudens was chosen as part of a team of artists and artisans that produced the decorative work for the interior of the house. He had worked with La Farge earlier on the decorations for Trinity Church (1877), Boston, designed by Henry H. Richardson, as well as the reredos "Angels Adoring a Cross" for St. Thomas Church (1877) in New York City.

21 and 22. *Putti Panels,* Cornelius Vanderbilt II House, New York City, 1882–83. Wood, ivory, mother-of-pearl, iridescent metal; $27\frac{3}{8} \times 15\frac{3}{4}$ inches. Saint-Gaudens National Historic Site, Cornish, N.H. (SAGA nos. 5206, 5207). Gift of Christopher Forbes, Timothy Forbes, and James Maroney, Inc., 1988.

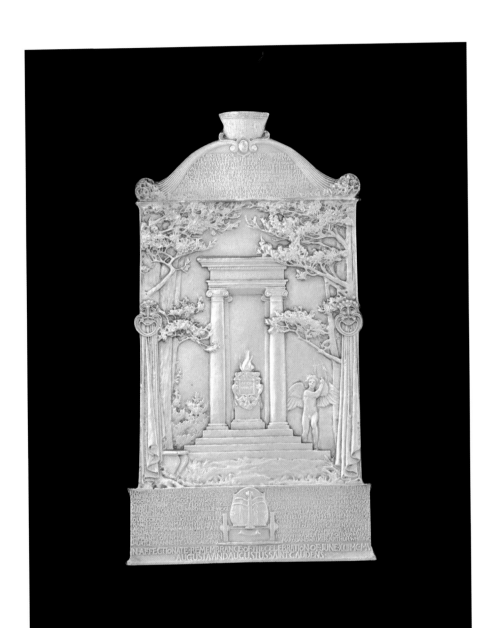

The *Ceres Panel* (see page 46) for the Vanderbilt House was part of an ensemble of primarily allegorical panels—including panels of Bacchus, Pomona, and Actaeon or Vertumnus—mounted in the upper walls and ceiling of the forty-five-foot-long dining room. These were inspired by ancient Byzantine ivories and Pompeian fresco wall paintings, drawn by La Farge from his extensive library of volumes on ancient art. The ceiling was divided into twenty panels, the central six filled with opalescent glass and jewels. The coffer beams were inlaid with mother-of-pearl in a Greek fret pattern. At the ends and corners were panels centered with a sunburst head of the young Apollo (now part of the collection of the Smithsonian American Art Museum) flanked by puttis (cupids). The dining room was further enhanced with large rectangular relief portraits by Saint-Gaudens in gilded bronze of the grandfather, Cornelius I (1794-1877) (see page 30), and his great-grandchildren: Gertrude, age seven (see page 31), and her brothers, William Henry II, age eleven, and Cornelius III, age eight (see page 30). The decorations for the dining room were equaled in artistic quality by the entrance hall's great Numidian marble mantelpiece (given in 1925 by Mrs. Cornelius Vanderbilt to the Metropolitan Museum of Art). The mantelpiece was supported by robed female caryatids, *Love* and *Peace,* modeled by Saint-Gaudens, and crowned with a framed overmantel mosaic. The caryatids are directly related to Saint-Gaudens's commission for the tomb of Edwin D. Morgan, former governor of New York, at Cedar Hill Cemetery in Hartford, Connecticut (see page 87).

The decorations for the Villard House in New York City might be more properly attributed to the sculptor's brother, Louis St. Gaudens.[3] However, here again, the services of a team of artists and artisans were required. The sculptural program called for a great zodiac clock carved in marble and mounted into the wall, a large fireplace at the entrance, and decorations and a fireplace for the second-floor dining room. In the dining room on either side of the mantelpiece were two recessed basins carved in marble and depicting dolphins springing from ripples of water. During Saint-Gaudens's lifetime the dolphin font was recast in bronze from the model from the Villard House.

Financial reverses forced Henry Villard into bankruptcy in 1884–85, and he sold the Madison Avenue complex to another newspaper publisher, Whitelaw Reid. Eventually the properties, which were across from St. Patrick's Cathedral, came into the possession of the Archdiocese of the City of New York. Since 1976 the three landmark buildings on Madison Avenue have been transformed into the Helmsley Palace Hotel, although the exterior façades have been preserved.

23. *Cornish Celebration Presentation Plaque,* 1905–6. Silverplate, 3³⁄₁₆ × 1⅞ inches. American Numismatic Society, New York (inv. no. 1961.137.3).

55

THE MONUMENTS

THE CIVIL WAR

Following the end of the Civil War in 1865, there was a great public call for monuments and memorials dedicated to the leaders and soldiers on both sides of the conflict. Saint-Gaudens responded to this need with some of his most powerful sculptures. Through the *Standing Lincoln* in Chicago, the monuments to Admiral David Farragut and William Tecumseh Sherman in New York City, and the great *Shaw Memorial* in Boston, Saint-Gaudens presented to the country works that changed the public perception of civic sculpture. Of the hundreds of Civil War–inspired monuments, his works stand out for their quiet dignity and inherent strength of character.

FARRAGUT MONUMENT

Admiral David Glasgow Farragut (1801–70), one of the great heroes of the Civil War, was the subject of Saint-Gaudens's first major public commission. Unveiled in New York City's Madison Square Park on Memorial Day, 1881, it immediately received high praise. The monument (see page 25) was also Saint-Gaudens's first collaboration with the architect Stanford White. The monumental bronze is set on top of a unique exedra (semicircular stone bench) and pedestal with carved reliefs of seated female figures, *Loyalty* and *Courage*. A lengthy inscription carved on the base recounts the life of the victor of the Battle of New Orleans. The monument's base is perhaps the first use of the Art Nouveau style in American sculpture. Along with the inscriptions, in relief on the front and back of the great exedra, Saint-Gaudens incorporated symbols of sea life—dolphins and waves—as well as the icons of a seaman's life.

24. *Admiral David Glasgow Farragut,* 1875–78. Plaster, 21½ × 18½ × 15 inches. Saint-Gaudens National Historic Site, Cornish, N.H. (SAGA no. 893).

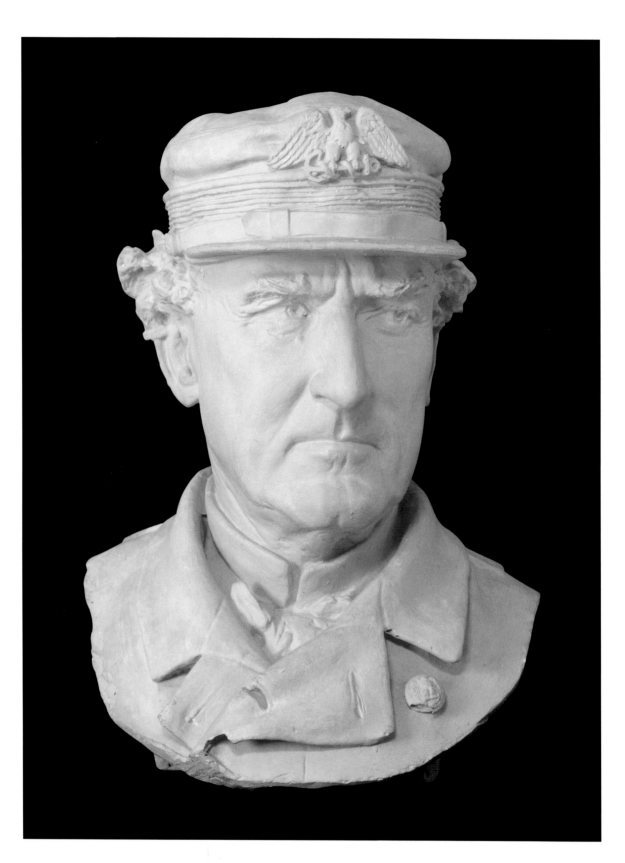

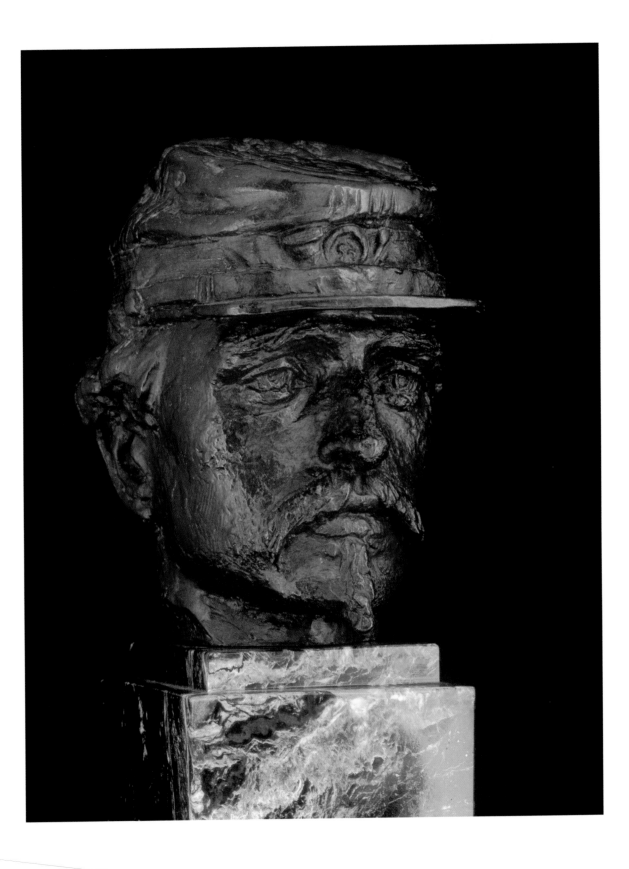

Of the great abundance of monuments produced in the United States following the Civil War, perhaps no other is more reflective of that great conflict than the *Shaw Memorial* by Saint-Gaudens. Commissioned by the Commonwealth of Massachusetts, the monument (see page 120) memorializes Colonel Robert Gould Shaw (1837–63) and his regiment, the Massachusetts Fifty-fourth, the first unit of African Americans in the Union Army. Shaw (opposite), the son of staunch abolitionists from Boston, died with many of the men in the assault on Fort Wagner, South Carolina, on July 18, 1863. Saint-Gaudens worked on the monument for fourteen years, beginning in 1884 until its unveiling in Boston on May 31, 1897. Even after its unveiling, the sculptor continued to work on the monument, exhibiting a reworked monumental plaster cast in Paris in 1898 and again in 1900. That unique cast was brought back to be exhibited at the Pan American Exposition in Buffalo, New York, in 1901.

The composition grew from the original concept of an equestrian statue of Shaw alone to a great sculptural relief that includes the marching men. The twenty-three individually modeled faces of the infantrymen in the final piece are represented in five sketch models (see pages 60–62) from the forty originally done. These heads, modeled from life, provided the sculptor a full range in age and character. Moreover, the work represents perhaps the first time that African Americans were represented realistically in sculpture, not as stereotypes. Nevertheless, added to this realistic portrayal were the poetic and allegorical tones that Saint-Gaudens always tried to include in his work. Thus an angel—of death or perhaps peace—(see page 63) appears in the background above the regiment. As Saint-Gaudens noted: "[I]t's the feeling of death and mystery and love."[4]

25. *Shaw Memorial, Robert Gould Shaw Head,* 1883–93. Bronze, 1908, 10 × 8 × 10 inches. Saint-Gaudens National Historic Site, Cornish, N.H. (SAGA no. 904).

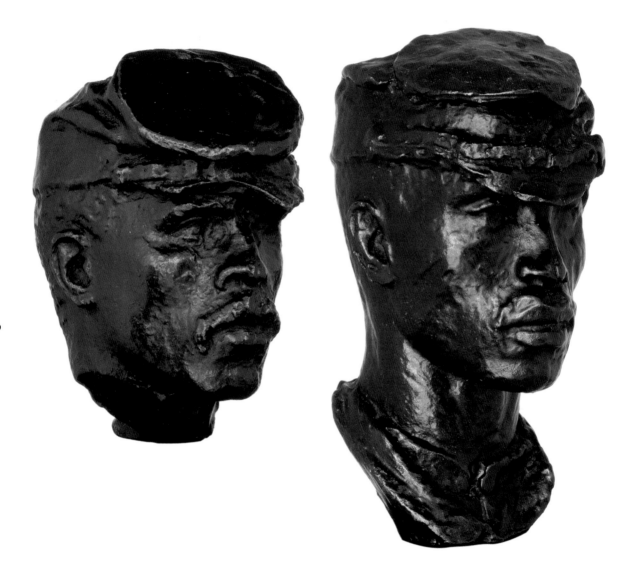

26. *Shaw Memorial, Soldier's Head,* 1883–93. Bronze,
1965, 5¾ × 3¾ × 5½ inches. Saint-Gaudens National
Historic Site, Cornish, N.H. (SAGA no. 887).

27. *Shaw Memorial, Soldier's Head,* 1883–93. Bronze,
1965, 7½ × 3¾ × 5½ inches. Saint-Gaudens National
Historic Site, Cornish, N.H. (SAGA no. 886).

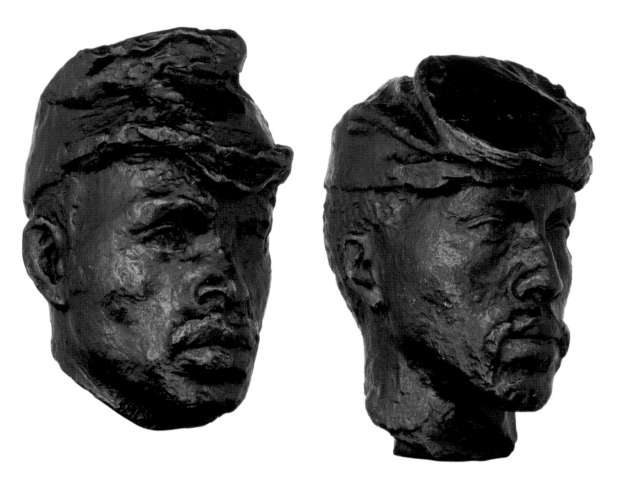

28. *Shaw Memorial, Soldier's Head,* 1883–93. Bronze, 1965, 5¾ × 3¾ × 5½ inches. Saint-Gaudens National Historic Site, Cornish, N.H. (SAGA no. 885).

29. *Shaw Memorial, Soldier's Head,* 1883–93. Bronze, 1965, 5¾ × 3¾ × 5½ inches. Saint-Gaudens National Historic Site, Cornish, N.H. (SAGA no. 888).

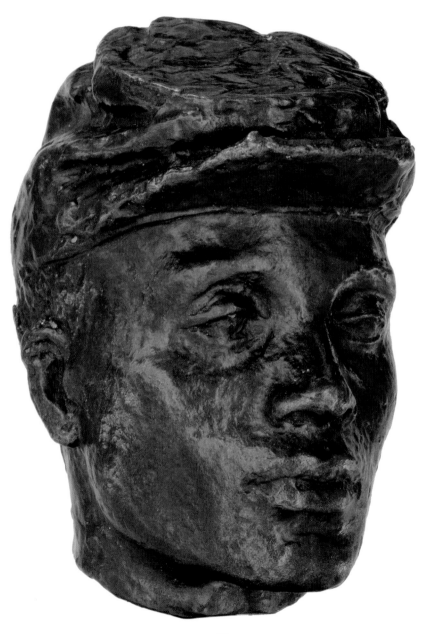

30

The architect responsible for the installation of the monument in Boston was Saint-Gaudens's friend Charles F. McKim, not Stanford White, the sculptor's earlier collaborator and McKim's partner. Taking into account the nature of the site on Beacon Street above Boston Common, McKim incorporated the bronze into a great stone balustrade and arched framework, keeping the monument close to the level of the viewer on a terrace set slightly back from the busy street. The back of the frame is a finished stone wall with a fountain below and panels of carved inscriptions prepared by Charles Eliot, president of Harvard University. The names of the enlisted men of the regiment killed in action during the war were added at the time of the monument's restoration in 1981. This great monument has been a source of inspiration for poetry, essays, prints, exhibitions, sculptures, photographs, and films.[5]

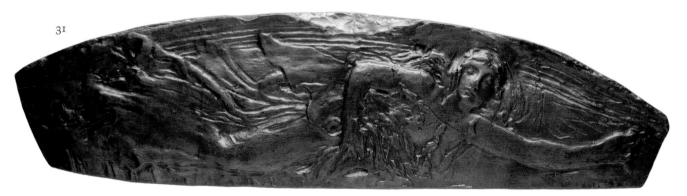

31

30. *Shaw Memorial, Soldier's Head,* 1883–93. Bronze, 1940s, 5¾ × 3¾ × 5½ inches. Saint-Gaudens National Historic Site, Cornish, N.H. (SAGA no. 80). Gift of the Trustees of the Saint-Gaudens Memorial and John O'Connor.

31. *Shaw Memorial, Ideal Figure (Angel),* ca. 1884. Bronze from plaster sketch, 1920, 10 × 37 inches. Brooklyn Museum of Art, Brooklyn, New York. Purchased from Mrs. Augusta H. Saint-Gaudens.

ABRAHAM LINCOLN

The end of the Civil War and the subsequent reconstruction that followed led to an outpouring of pride in the nation's war heroes. Chief among these was the slain president, Abraham Lincoln. Following his death in 1865, the country, overwhelmed with grief, was transfixed by the solemnity of the funeral and the ceremonies that accompanied the procession of his remains to their final resting place in Illinois. Saint-Gaudens, then twelve years old, first saw the president-elect in 1860 in New York City. He wrote: "Lincoln stood tall in the carriage, his dark uncovered head bent in contemplative acknowledgment of the waiting people, and the broadcloth of his black coat shone rich and silken in the sunlight."[6] A year later, when Saint-Gaudens was working as a cameo carver, he saw regiments marching off to the war, and in 1865 he was one of the great mass of mourners who viewed the president's body lying in state in New York City. All these events made a lasting impression on Saint-Gaudens. In November 1884 he welcomed a commission for a major monument to Lincoln to be erected in Chicago.

The following spring Saint-Gaudens was invited by a friend, the lawyer Charles Cotesworth Beaman (see page 102), to visit his summer residence along the Connecticut River in Cornish, New Hampshire. Beaman suggested that the Saint-Gaudenses, known to their friends as Gus and Gussie, rent an adjoining property, which he had purchased in 1884, enticing the artist with the probability that he could find a local model to pose for the Lincoln statue. That summer, in 1885, Saint-Gaudens took the house, which he later named Aspet in honor of his father's birthplace in France, and converted the hay barn into a studio, installing windows along the long side of the barn to allow an abundance of northern light.

32. *Head of Lincoln,* 1887. Bronze, after 1907, 16½ × 11 × 11½ inches. Saint-Gaudens National Historic Site, Cornish, N.H. (SAGA no. 793).

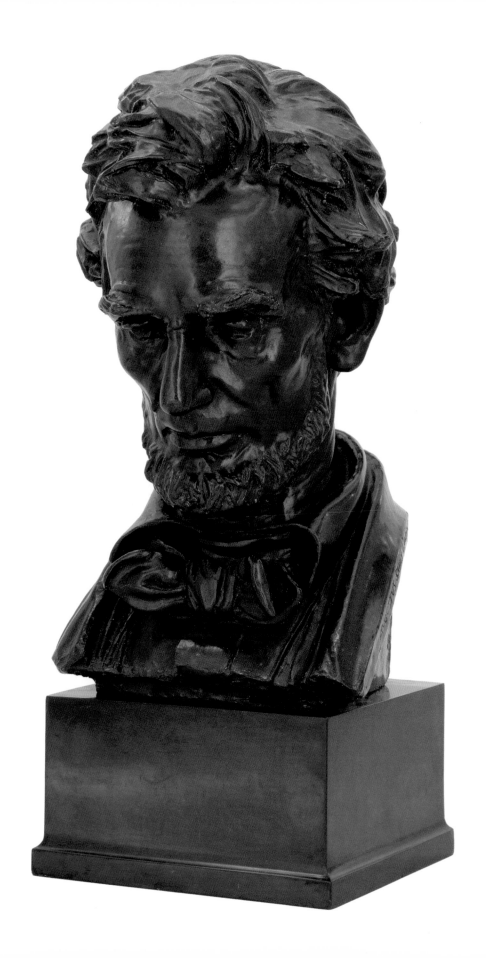

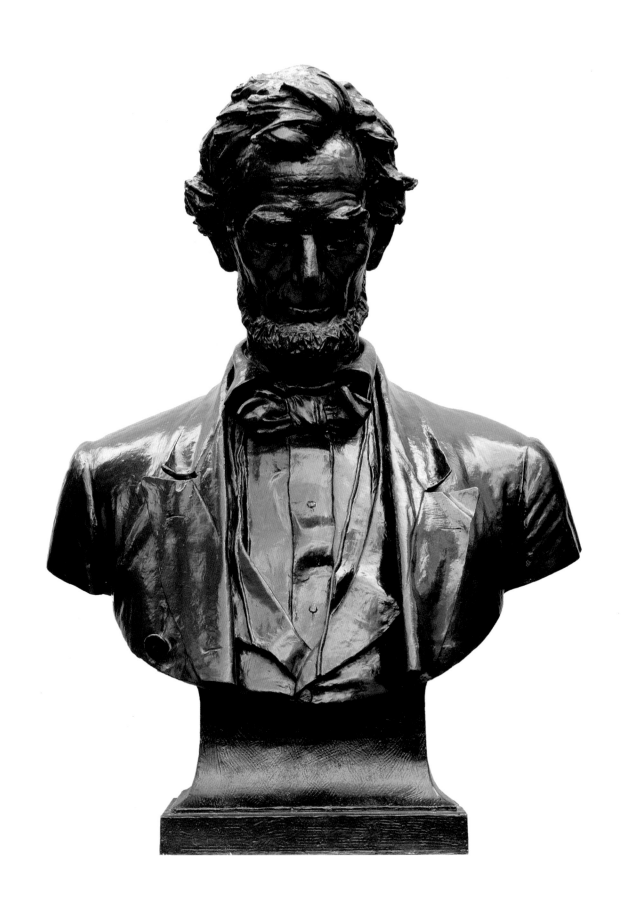

Other artists, primarily painters, followed Saint-Gaudens to Cornish. Henry O. Walker (1843–1929), Thomas W. Dewing, Kenyon Cox (1856–1919), Henry Fuller (1867–1934), Maxfield Parrish (1870–1966), and Charles Platt (1861–1933), together with Saint-Gaudens's studio assistants, comprised a vibrant summer community of like-minded friends with shared experiences. Most resided in New York City in the winter, almost all had worked or studied in Paris, and many shared friendships with other artists in those two cities, including John Singer Sargent, Stanford White, Jules Bastien-Lepage (1848–84), and William Merritt Chase (1849–1916) (see page 99). In 1877 a number of them joined together to form the Society of American Artists. By the 1890s the Cornish Colony, as it became known, included not only sculptors and painters but also writers, musicians, dramatists, architects, and landscape architects.

It was in his Cornish studio that Saint-Gaudens began work on the Lincoln Monument. Saint-Gaudens chose the standing pose, so appropriate to Lincoln, recalling perhaps his Gettysburg Address at the dedication of the battlefield as a national cemetery in November 1863. The sculptor included an empty chair of state, lending drama to the humble figure of the president. From among the New England farm communities he found a model, a man the same height and build as Lincoln. Striving for vitality and realism, Saint-Gaudens had the model walk around the fields in clothes similar to those of the president and had detailed photographs taken so that the sculptor could refer to them when forming the clay. That winter, in 1885–86, he was also fortunate in locating a plaster cast of Lincoln's hand and face, made by Leonard W. Volk in Chicago in 1860, which he used to produce the final figure.

The monument (see page 5), on the back of which are inscribed selections from Lincoln's speeches, was completed in 1887 and was unveiled at a ceremony that October. Stanford White, with whom Saint-Gaudens was then collaborating on *The Puritan* in Springfield, Massachusetts, designed the setting, which included a great exedra (semicircular bench) on a raised stone platform accessed by a wide sweep of low steps. In 1878 Saint-Gaudens and White, along with the architect Charles McKim, had traveled throughout France, observing the great monuments of that country. Later, beginning with their work on the *Farragut Monument* in 1881, their first artistic collaboration, Saint-Gaudens and White took what they had learned and applied it to their own monument commissions.

33. *Abraham Lincoln, Bust, Heroic,* 1885. Bronze, 1910, 50½ × 44 × 29 inches. Saint-Gaudens National Historic Site, Cornish, N.H. (SAGA no. 939).

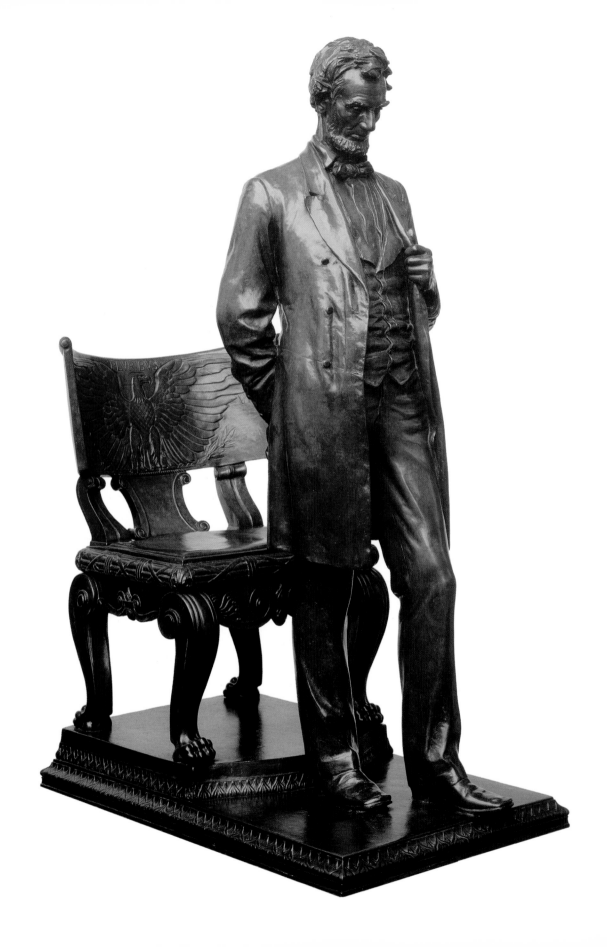

The *Standing Lincoln* is the epitome of everything that the sculptor and the associate architects sought to achieve in each of the major monuments on which they collaborated. In his monumental sculpture Saint-Gaudens always tried to balance realism with some dramatic or ideal elements that would make it easily accessible to the viewer, usually by using a lower pedestal than other sculptors of the time might have chosen. The inclusion of inscriptions on the architectural exedra, now a common feature of monuments, enhanced Saint-Gaudens's works and in the case of the Lincoln monument commemorated the president's achievements.

A measure of the Lincoln monument's popularity is that Saint-Gaudens was later asked to produce a smaller version of the statue for installation in the White House. Although Saint-Gaudens himself never made a smaller version, after his death in 1907 his widow created a bronze in a reduced size, cast by the Gorham foundry in 1910 (opposite). The life-size bronze cast of the head of Lincoln (see page 65) is also one of an edition produced by the artist's widow and continues to be a favored presentation piece, sometimes given by the U.S. government to heads of state. In addition, replicas have been made of the full monument: one is installed in Parliament Square, London, a gift of the Carnegie Endowment in 1920; another is in Forest Lawn Memorial Park cemetery in Hollywood; and a third is in Chapultipec Park in Mexico City, a gift of the United States in 1966.

34. *Standing Lincoln,* 1887. Bronze reduction, 1910, 47¼ × 15¾ × 27½ inches. Saint-Gaudens National Historic Site, Cornish, N.H. (SAGA no. 879).

SHERMAN MONUMENT

Toward the end of his career, Saint-Gaudens was awarded the commission for a monument to honor William Tecumseh Sherman (1820–91), the renowned Union general of the Civil War who was made a general of the army by President Ulysses Grant in 1869. After his retirement in 1883, Sherman had moved to New York City, where Saint-Gaudens modeled in clay the bust of the general in 1888. Work began on the *Sherman Monument* in Saint-Gaudens's New York studio in 1892 and continued in Paris following exhibition of the full-scale plaster model at the 1900 Éxposition Universelle. After Saint-Gaudens's return to the United States, he set up a duplicate heroic-size plaster cast in his studio in Cornish, New Hampshire, where he continued to perfect the monument (see page 37). These changes were then sent to his assistants in Paris, where the monument was cast in bronze. The finished bronze was shipped home to Cornish and set up in the field adjoining the studio to be toned and gilded before its unveiling on May 30, 1903, at the entrance to Central Park in New York City (see pages 6–7).

In 1897 the Swedish artist Anders Zorn (1860–1920) visited Saint-Gaudens's New York studio at the time the *Victory* figure for the *Sherman Monument* was being modeled there. The *First Study for the Head of Victory* (right) was actually a portrait of Hettie Anderson, the model for the *Victory* figure (she is also depicted in Zorn's famous etching *Saint-Gaudens and His Model)*. Saint-Gaudens continued to work on the *Victory* in Paris, where he refined the head and figure. Following the unveiling of the monument in 1903, Saint-Gaudens began an edition of *Victory* heads (known as *Second Study for the Head of Victory*) that are found in public and private collections today. Following Saint-Gaudens's death, his widow produced gilded bronze reductions of the full figure (opposite) that are today included in retrospective exhibitions of the sculptor's work and collected throughout the country.

The architecture and setting of the *Sherman Monument* were designed by Charles McKim. A. Phiminster Proctor (1865–1920) assisted in the modeling of the horse, and James Earle Fraser (1876–1953) worked with Saint-Gaudens on the project both in Paris and in New Hampshire. Fraser later wrote in his autobiography: "As I recall it there were fifteen of us working at one time. . . . It was like Donatello at Padua except he had 21 sculptors to help him."[7]

35

35. *Hettie Anderson, First Study for the Head of Victory, Sherman Monument,* 1897. Bronze, after 1908, 13 × 5 × 7 inches. Hagans Family Collection, Detroit, Mich.

36. *Sherman Monument, Victory,* 1897–1902. Bronze reduction, 1912, 40 × 14 × 22 inches. Saint-Gaudens National Historic Site, Cornish, N.H. (SAGA no. 940). Gift of Charles D. Norton, 1924.

37. *Sherman Monument,
Head of Victory, Heroic,*
1897-1902. Plaster, 24
× 19 × 22 inches. Saint-
Gaudens National
Historic Site, Cornish,
N.H. (SAGA no. 64)

38. *NIKH-EIPHNH,
Relief of Victory,* 1903–7.
Bronze, 9¾ inches
diameter. Saint-Gaudens
National Historic Site,
Cornish, N.H. (SAGA
no. 82).

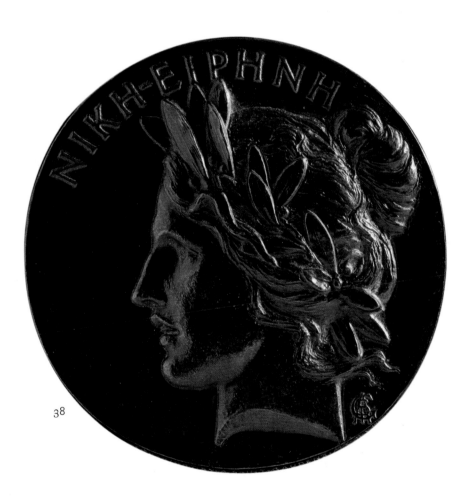

38

73

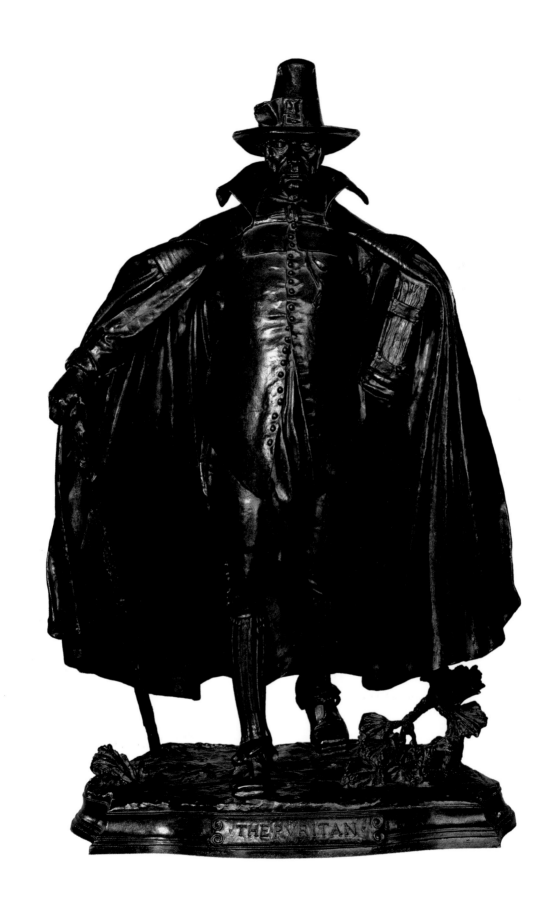

THE PURITAN

39. *The Puritan,* modeled 1886; reworked, reduced, and cast after 1899. Bronze, 31 × 19½ × 12¾ inches. North Carolina Museum of Art (G.71.40.9). In memory of Katherine Clark Pendleton Arrington (from her own collection) by her nephew and niece, Mr. and Mrs. Fabius B. Pendleton.

One of the most evocative of Saint-Gaudens's monuments is *The Puritan,* designed for a site in Stearns Park in Springfield, Massachusetts. Dedicated in 1887, the sculpture is not a generalized view of the early founders of the Massachusetts Colony but a carefully researched portrayal of a specific one, Deacon Samuel Chapin (1595–1675). The commission for the monument came to Saint-Gaudens from Chester W. Chapin, one of Chapin's descendants, whose family provided details for the costume, taken from early prints. The face was modeled on Saint-Gaudens's bust (1881) of Chester Chapin; the model for the figure was a man named Van Ortzen.

The site, designed by Stanford White, included the monument, placed on a circular base of red beach granite, and a circular pool with four bronze turtles and a central sphere. In 1899 the monument itself was moved to Merrick Park. The sphere remains in the pool at Stearns Park, but the turtles have been removed, awaiting restoration.

The bronze reduction (opposite) is one of a series first created in the 1890s. Influenced by French artists such as Antoine-Louis Barye and his student Frederick MacMonnies, who had been successful in producing reduced versions of his *Bacchante,* Saint-Gaudens first created reductions of *The Puritan, Diana,* and *Robert Louis Stevenson* in Paris. Later casts were made in the United States. In 1903 a slightly different version of the statue was installed in Fairmount Park, Philadelphia, and called *The Pilgrim* to distinguish it from the earlier work.

THE FEMALE FIGURE

In Saint-Gaudens's depictions of the female figure, the true grace and beauty of his technique are clear. Among the most familiar of his works are the *Amor Caritas, Morgan Tomb Angels, Diana,* and *Adams Memorial.* All very different, these figures reflect the changing approach to the human form as Saint-Gaudens matured. The earliest figures, *Amor Caritas* and the *Morgan Tomb Angels,* show the influence of Pre-Raphaelite imagery in the almost dreamlike quality of the face and the flowing drapery. The *Diana,* Saint-Gaudens's only nude female figure, embodies the timeless beauty of the classical art that inspired it. Finally, the *Adams Memorial,* with its mystery and power, reflects the strength of emotion and the all-encompassing spirit that Henry Adams and the sculptor sought to achieve. Whether earthly or spiritual, Saint-Gaudens's sculptures of the female form are immediately appealing.

40. *Davida Johnson Clark, First Study for the Head of Diana,* 1886. Marble, 11 × 7⅛ × 7½ inches. Saint-Gaudens National Historic Site, Cornish, N.H. (SAGA no. 96).

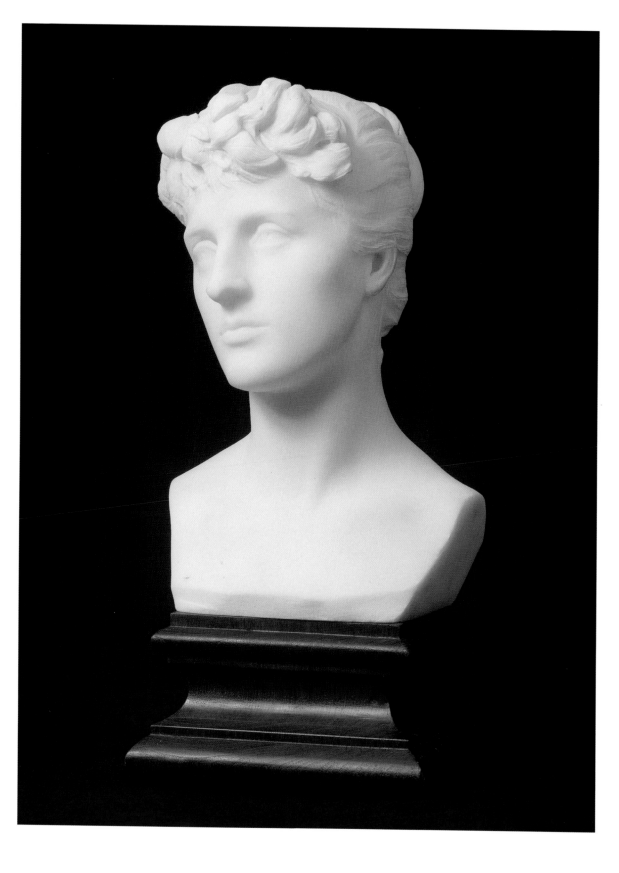

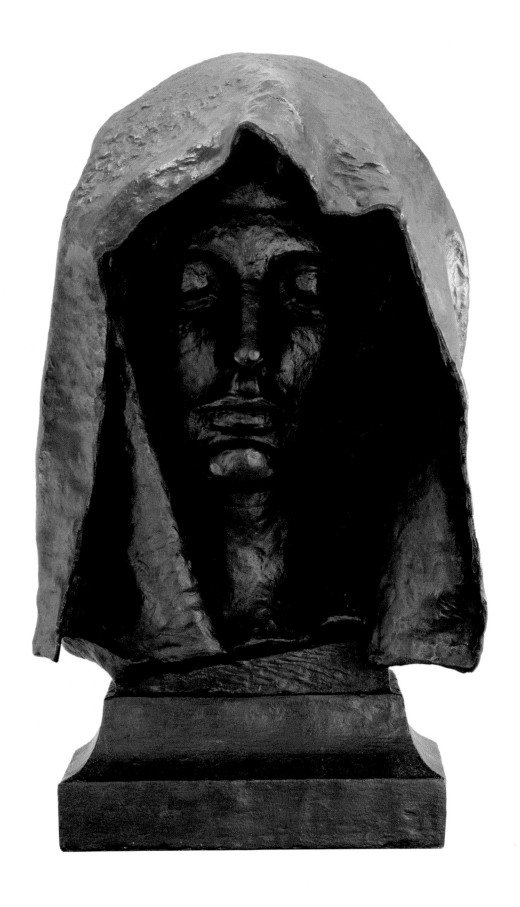

In 1886 the historian Henry Adams, great-grandson of the nation's second president, commissioned a monument for his own grave site and that of his wife, Marian Hooper Adams, who had died by her own hand in 1885. Adams settled on the idea for the monument following a trip to Japan with the painter John La Farge. Adams directed Saint-Gaudens to have La Farge provide him with Buddhist writings, as well as descriptions and images of some of the major monuments to Buddha. He also directed the artist to refer to the paintings of Michelangelo, especially the sibyls from the Sistine Chapel ceiling in the Vatican. After several years Saint-Gaudens created what has been called the most unusual work of his career, a synthesis of male and female characteristics and of Eastern and Western visual references. The bronze was completed in 1891 and installed in the Rock Creek Cemetery of St. Paul's parish, Washington, D.C. Stanford White, architect of the project, created an outdoor room with a curved granite bench, which rests on a boulder opposite the bronze. The sculpture (see page 1) is set on a slightly raised platform of pink granite with a floor of washed gravel in front of it, the whole surrounded by clipped evergreens.

41. *Adams Memorial, Model for the Head,* 1892–93. Bronze, 1908, 19 × 12 × 8 inches. Saint-Gaudens National Historic Site, Cornish, N.H. (SAGA no. 884).

The mystery of the sculpture is not mitigated by inscriptions of any kind. Indeed, Adams insisted that no name be associated with the work, although through its long history the work has acquired such nomenclature as "Grief" and "Nirvana." In 2002 the site was carefully restored and the plantings were renewed to retain the character of an outdoor room. The meditative quality of the work has been the source of great comfort and consolation to those who have found their way to the cemetery.

In 1892, in conjunction with a visit to the United States by the famous Polish pianist Ignacy Paderewski, Saint-Gaudens was asked to rework the head as a gift for the pianist, but the sculptor resisted. The head continued to entice, however. On a visit to Saint-Gaudens's studio, the architect Daniel Burnham, who was working with Saint-Gaudens on preparations for the 1893 World's Columbian Exposition in Chicago, found there a study for the *Adams* head in pieces on the floor and amused himself by reconstructing it. Saint-Gaudens offered to fix the piece and gave it to Burnham as a gift. That plaster, part of the memorial retrospective exhibition that toured the United States in 1908–10 soon after the sculptor's death, was the basis for a small edition of bronze casts made by Augusta Saint-Gaudens (opposite).

79

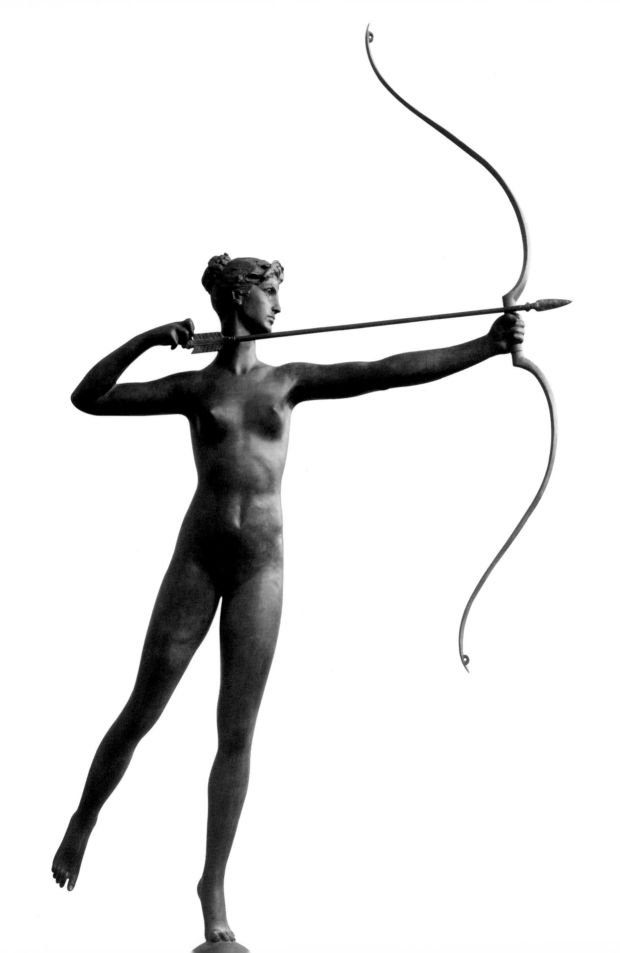

DIANA

Saint-Gaudens created his only extant figure of a female nude between 1886 and 1891, while Stanford White was designing Madison Square Garden in New York City. White was one of a group of investors who organized and financed the development of the new large-scale indoor sports and events arena in New York City, whose architectural style he borrowed from the Giralda Monument in Seville, Spain. The building's 347-foot tower was crowned by Saint-Gaudens's *Diana*—an eighteen-foot hollow figure of copper produced by a Salem, Ohio, manufacturing company—set on top as a weather vane. When it was installed amid great fanfare in October 1891, the sculpture was the highest feature in the New York City skyline. For the gala event White made New York's first spectacular use of the Edison light bulb, stringing 6,600 bulbs around the Garden's outer walls and lavishing an additional 1,400 more on the tower. In addition, ten giant arc lights were trained on the gilded weather vane.

However, it soon became clear that the figure was too big in proportion to the tower. The following year the figure was removed—at the artist's expense—so that he could rework it to a height of thirteen feet. The new figure was installed in 1894. The original eighteen-foot figure was reused as the finial on the dome of McKim, Mead, and White's Agriculture Building at the World's Columbian Exposition in Chicago in 1893 but was subsequently lost in the fire that destroyed the empty exposition buildings in 1894. The thirteen-foot figure remained on Madison Square Garden until 1925, when the building was torn down; it was then given to the Philadelphia Museum of Art.

42. *Diana, Second Version, Half Size,* cast 1972–73. Bronze, 78 × 51⅜ × 26 inches. Saint-Gaudens National Historic Site, Cornish, N.H. (SAGA no. 1649). Gift of the Trustees of the Saint-Gaudens Memorial.

In 1894, in conjunction with the new installation on Madison Square Garden, Saint-Gaudens began producing a reduction of the *Diana*. The first of several editions, copyrighted in 1895, was thirty-one inches in height and made by the Aubry Brothers Foundry in New York City. In 1899 Saint-Gaudens began to produce another edition in Paris. These pieces measure twenty-one inches in height and were often mounted on a tripod base of Renaissance design featuring griffin heads and inscribed "Diana of the Tower."

The *Diana* referred to as the "Half Size" (see page 80) is half the size of the thirteen-foot bronze that stood on top of Madison Square Garden in New York. The cast was made in 1972 by the trustees of the Saint-Gaudens Memorial, taken from an original plaster in the collection of the Saint-Gaudens National Historic Site.

The small sculpture of Diana on a tripod (opposite) is one of a series of reduced versions made by Saint-Gaudens beginning in 1895. Examples such as this, mounted on a Renaissance-style base, were part of the second edition of bronze reductions.

Although Saint-Gaudens did not number his editions, it is obvious from the examples in public and private collections that the *Diana* was a popular work and a financial success for the sculptor and his family. They were sold through Tiffany and Company in New York City and Paris as well as through other art dealers in Chicago and Boston.

43. *Diana, Second Version, on tripod,* 1894–95. Bronze reduction on tripod base, 1899, 23^{15}⁄$_{16}$ × 15 × 12½ inches. Saint-Gaudens National Historic Site, Cornish, N.H. (SAGA no. 890).

AMOR CARITAS AND MORGAN TOMB ANGELS

The *Amor Caritas* is a standing winged figure of monumental size in high relief. A girdle of passion flowers gathers the robe at the figure's waist, and a wreath of flowers crowns her head. Her arms are upraised, bearing a tablet on which is inscribed the phrase "Amor Caritas," which Saint-Gaudens may have interpreted as "the love of the spirit" but which translates literally as "earthly and spiritual love."

The *Amor Caritas* is a reworking of an 1879 commission (see page 87) for a family tomb commissioned by Edwin D. Morgan, former governor of New York. For the Morgan project, the sculptor developed a group of three robed female figures surrounding a cross. The central figure holds an open scroll between her two outstretched hands; on the front of the plinth on which she stands is inscribed the phrase "Gloria in Excelsis Deo." The monument was to be installed in Cedar Hill Cemetery, Hartford, Connecticut, but Morgan died in 1883, the models were destroyed by fire, and the project was abandoned. The central figure was reproduced in a print as the frontispiece of *Book of American Figure Painters* (1886), by Mariana Griswold Van Rensselaer (see page 97).

A year later a commission for the Anna Maria Smith tomb at Island Cemetery in Newport, Rhode Island, provided an opportunity for Saint-Gaudens to utilize the central figure from the Morgan project. Although credited to his brother, the sculptor Louis St. Gaudens, the monument incorporates the robed figure, now winged, holding a tablet bearing an inscription above her head. It is thought that the head (opposite) was sculpted from Saint-Gaudens's mistress and model, Davida Johnson Clark. She is also the source of the marble *First Study for the Head of Diana* (see page 77), which Saint-Gaudens always kept in his studio. A plaster of the head was passed down in Clark's family and sold at auction in recent years. Saint-Gaudens returned to this rendition in two subsequent commissions: the *John Hudson Hall Tomb* (1891) in Sleepy Hollow Cemetery, Tarrytown, New York, and the *Maria Mitchell Memorial* (1902) in St. Stephen's Church, Philadelphia.

44. *Amor Caritas, Angelic Head,* 1886. Plaster, 18½ × 17 × 8 inches. Saint-Gaudens National Historic Site, Cornish, N.H. (SAGA no. 894).

45. Augustus Saint-
Gaudens and Louis St.
Gaudens, *Amor Caritas,
Head, Anna Maria Smith
Tomb,* 1887. Plaster,
16½ × 10½ × 7½ inches.
Saint-Gaudens National
Historic Site, Cornish,
N.H. (SAGA no. 892).

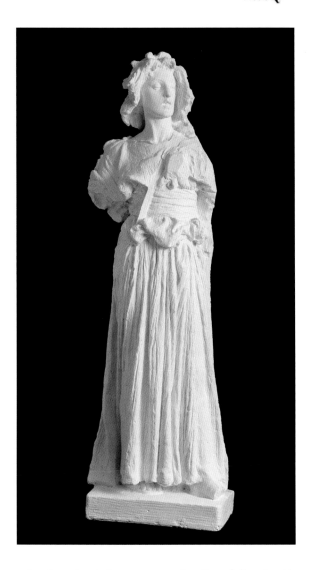
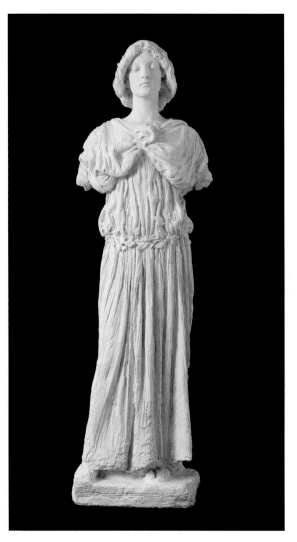

46 and 47. *Angels for the Tomb of Edwin Morgan,* 1879–80 (left), 1883 (right). Plaster, 38¾ × 14 × 7 inches (left), 38¾ × 12¾ × 6 inches (right). Saint-Gaudens National Historic Site, Cornish, N.H (SAGA nos. 3802 and 3803).

In 1899, following the exhibition of a plaster cast (opposite) of the *Amor Caritas*, also called *Angel with a Tablet,* the French government offered to purchase a bronze cast for the Luxembourg Palace Museum in Paris, a supreme honor reserved for living artists. Saint-Gaudens agreed to the purchase at cost (1,000 francs), to which he added a gift of fourteen bronze casts, all reductions of his bas-relief portraits (all now in the collections of the Musée d'Orsay, Paris). That same year Saint-Gaudens was named a corresponding member of the Institute of France. In 1900 the reworked *Amor Caritas* was exhibited in the Éxposition Universelle held in Paris, along with the bronze *Puritan* statue (see page 128), the monumental plaster cast of the reworked *Shaw Memorial,* and the heroic plaster cast of the *Sherman Monument.* It was this exhibition for which Saint-Gaudens received the Grand Prize and was named a corresponding member of the Société des Beaux Arts.

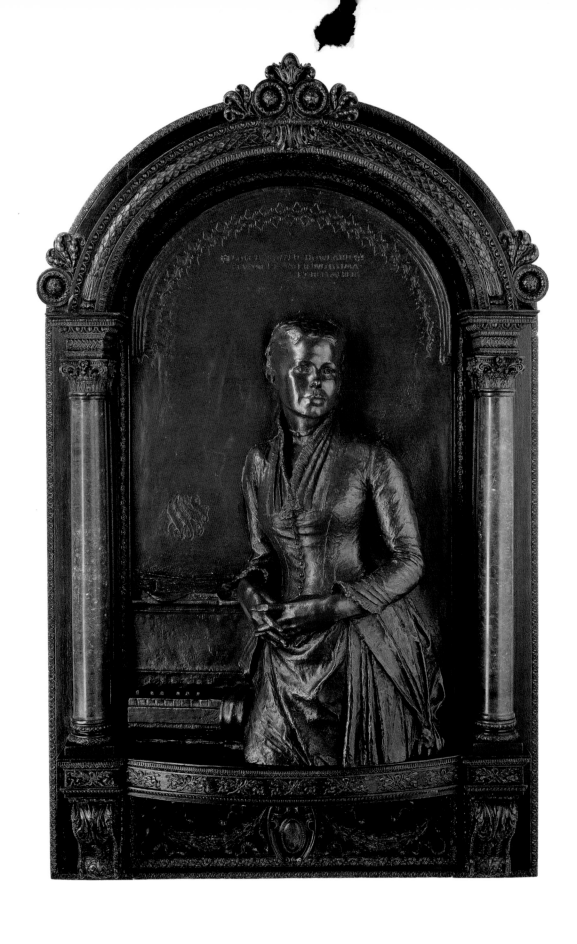

Saint-Gaudens is best known for his relief portraiture. Introduced to the form during his early years in Paris and Rome, he made his first relief portraits in New York City following his return to the United States in 1875. The painter John La Farge suggested that the sculptor try his hand at "painting" a bas-relief portrait, resulting in the first of a series of such portrayals over the sculptor's lifetime. He completed his first portrait in 1877, a bronze of the American artist David Maitland Armstrong, with whom he shared a studio. Although modeled in New York, the small bronze (7 by 5 inches) was cast in Paris and later presented to Armstrong. During a subsequent period of residence in Paris, from 1877 to 1880, Saint-Gaudens completed more than twenty bas-relief portraits of artists and friends. He continued to work in this medium throughout his career.

Critics consider Saint-Gaudens a master of the relief portrait in the style of the great artists of the Renaissance. In her essay "Refined Picturesqueness: Augustus Saint-Gaudens and the Concept of 'Finish,'" Thayer Tolles has provided new insight into the sculptor's development of the relief as a medium reflecting his personal manifesto: the "quality of a work of art [should] be judged on its character or effect, rather than on its degree of technical completion."[8] "Saint-Gaudens consistently employed a tighter, more polished style in his commissioned reliefs," she continues, "while reserving a looser technique for those portraits executed as tokens of friendship." Saint-Gaudens was consistently praised for the refreshing individuality of his portraits. "Remember that your background is your atmosphere, and part of the composition," he admonished his students and assistants, emphasizing that the composition should extend from edge to edge of the frame.[9]

48. *Louise Miller Howland,* 1888. Bronze, 39⅛ × 23½ inches. Frame designed by Stanford White. Private collection.

89

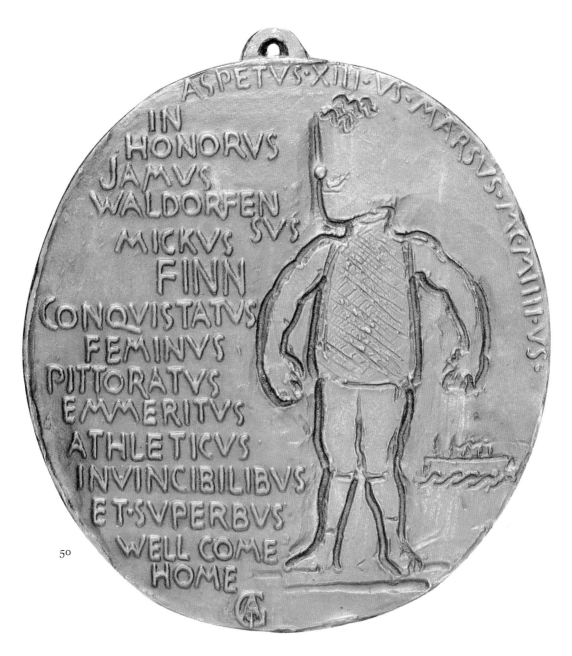

49. *Caricature Plaque of Charles F. McKim, Stanford White, and Augustus Saint-Gaudens*, 1878. Bronze, 6 inches diameter. The Century Association, New York. Gift of William Rutherford Mead, 1920.

50. *Caricature of James Wall Finn*, 1886. Bronze, 6⅝ inches diameter. Fred Finn.

Elements of an artist's personality become distinguishable in his or her work, and Saint-Gaudens's portrait reliefs vividly express facets of his own character. Basically reticent, he blossoms into poetry in the individual and decorative inscriptions, which he added to the relief portraits of friends. An example of his wit is captured in several caricatures or comic sketches, represented here in two medallions. One commemorates his pilgrimage to the great classical and medieval monuments of France with his friends Charles McKim and Stanford White (see page 90) in the summer of 1878, and the other is a humorous rendition of James Wall Finn (see page 91), depicted in 1904 in sports jersey and golf knickers, the steamship he traveled on to his honeymoon in France in the background.

The same attention to the sitter's personality is found in more formal portraits as well, including two of Dr. Walter Cary, one showing him wearing a hat, the other showing him hatless (see page 94). The sculpture of Cary's sister-in-law, Maria Maltby Love (see page 95), was one of his first bas-reliefs of a woman; another was that of Emelia Ward Chapin (see page 96), wife of Chester W. Chapin. The New York portraits of Helen Parrish Lee and her daughter Sarah Redwood Lee (see page 99), in a carved frame possibly by Stanford White, are enhanced by decorative elements capturing and highlighting the inscriptions. Saint-Gaudens later created a single portrait of Sarah Lee in vertical format. That relief and the one of Samuel Gray Ward (see page 100) were in Saint-Gaudens's own estimation his finest bas-relief portraits.

Although Saint-Gaudens usually chose a plain wood panel as a mount for his reliefs, in a few cases more elaborate frames were designed. The handsome frame holding his portrait of Dr. Henry Shiff (opposite)—a wide rectangle of reeded wood designed by Stanford White—augments the brilliant relief with its lengthy inscription detailing their mutual friendship and experience.

92

51. *Dr. Henry Shiff,* 1880. Bronze, 10⅞ × 11⁷⁄₁₆ inches. Frame designed by Stanford White. Saint-Gaudens National Historic Site, Cornish, N.H. (SAGA no. 875).

52. *Dr. Walter Cary,* 1878. Bronze, 8¾ × 6½ inches.
Maria L. Bissell, Ponte Vedra Beach, Fla.

53. *Maria Maltby Love,* 1879. Bronze, 9⅜ × 7⅛ inches.
Maria L. Bissell, Ponte Vedra Beach, Fla.

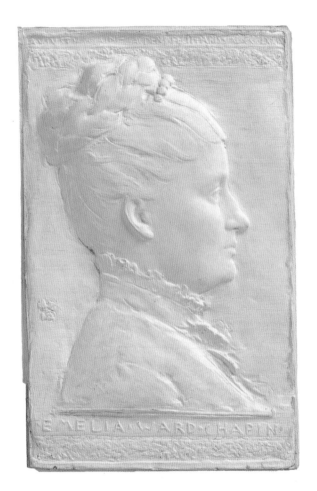

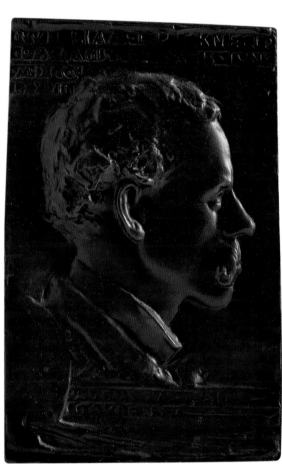

54. *Emelia Ward Chapin (Mrs. Chester W. Chapin),* 1879.
Plaster, 9½ × 6 inches. Saint-Gaudens National Historic
Site, Cornish, N.H. (SAGA no. 50).

55. *William L. Picknell,* 1878. Bronze, 7⁹⁄₁₆ × 4⅞ inches.
Saint-Gaudens National Historic Site, Cornish, N.H.
(SAGA no. 76).

56. *Mrs. Schuyler Van
Rensselaer (Mariana
Griswold),* 1888. Bronze,
1890, 20⁷⁄₁₆ × 7¾ inches.
The Metropolitan
Museum of Art (17.104).
Gift of Mrs. Schuyler
Van Rensselaer, 1917.

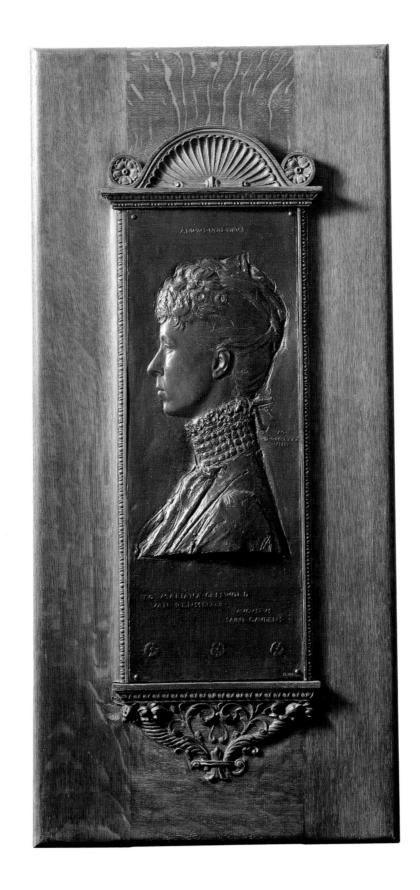

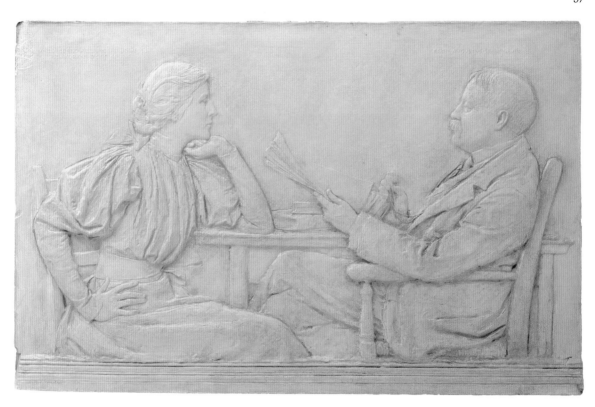

57. *Mildred and William Dean Howells,* 1897–98. Plaster, 24⅛ × 38¾ inches. Saint-Gaudens National Historic Site, Cornish, N.H. (SAGA no. 3379).

58. *Helen Parrish Lee and Sarah Redwood Lee,* 1881. Bronze, 14⅝ × 24⅛ inches. Frame possibly by Stanford White. Saint-Gaudens National Historic Site, Cornish, N.H. (SAGA no. 1868). Gift by purchase of the Trustees of the Saint-Gaudens Memorial, 1975.

59. *William Merritt Chase,* 1888. Bronze, 21⅝ × 29½ inches. American Academy and Institute of Arts and Letters, New York. Gift of Mrs. William Merritt Chase.

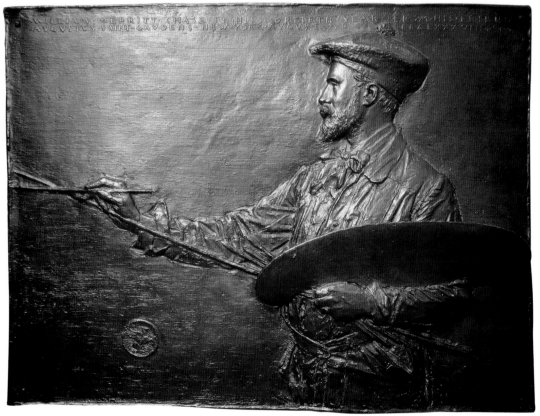

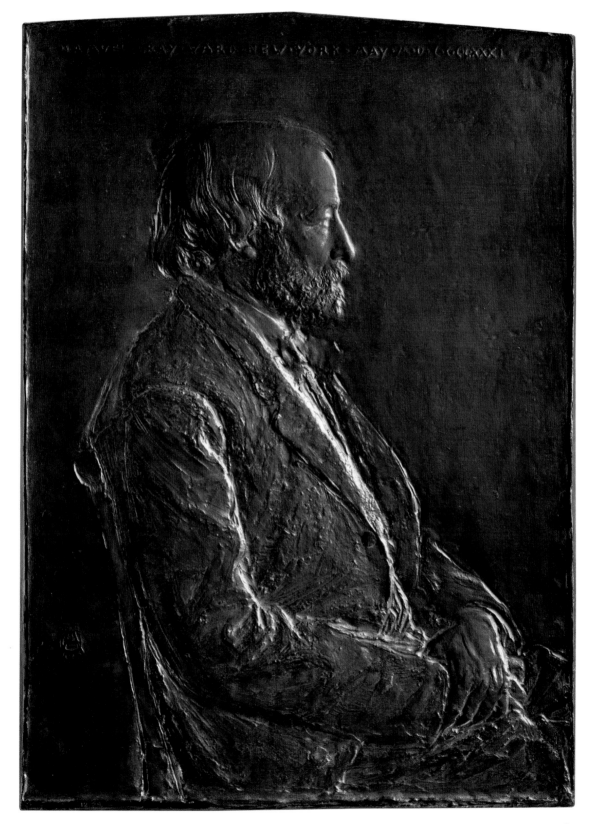

60. *Samuel Gray Ward,*
1881. Bronze, ca.
1908–9, 19 × 13¹³⁄₁₆
inches. The Metropolitan
Museum of Art, New
York (inv. no. 12.29).
Gift of Mrs. Augustus
Saint-Gaudens, 1912.

61. *Anna Lyman Gray,*
1902–4. Bronze, 35⅛
× 25⅝ inches. Saint-
Gaudens National
Historic Site, Cornish,
N.H. (SAGA no. 942).

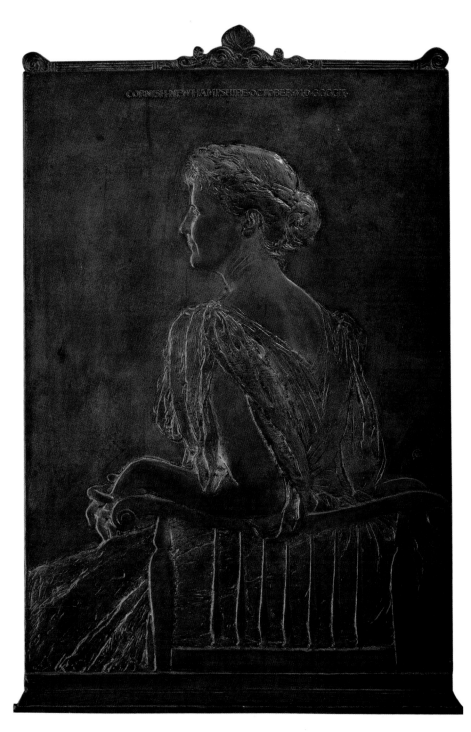

61

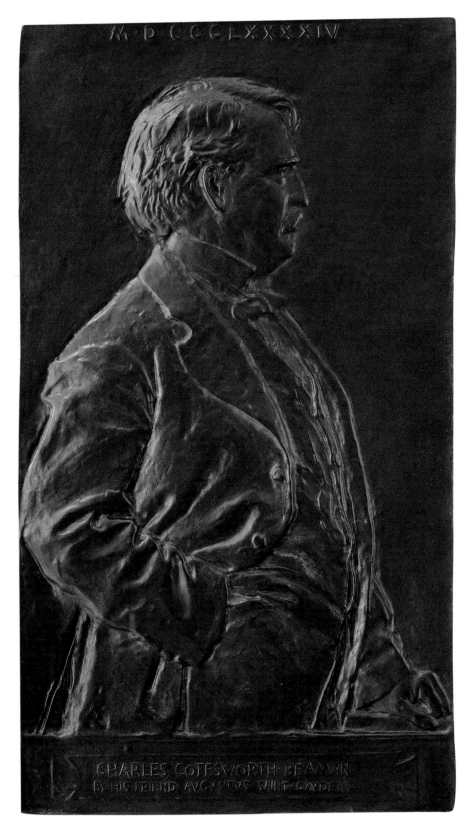

62. *Charles Cotesworth Beaman,* 1894. Bronze, 25¾ × 14¾ inches. Saint-Gaudens National Historic Site, Cornish, N.H. (SAGA no. 7113). Gift of Eric Lagercrantz, 1993.

63. *William M. Evarts,* 1888. Bronze, 23 × 10½ inches. Eben T. McLane.

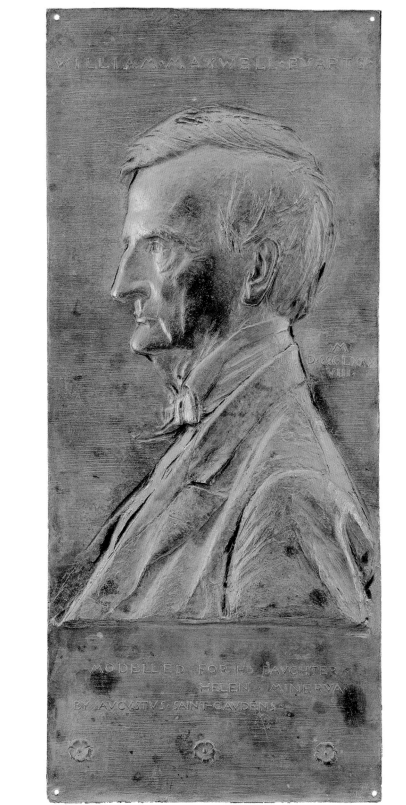

103

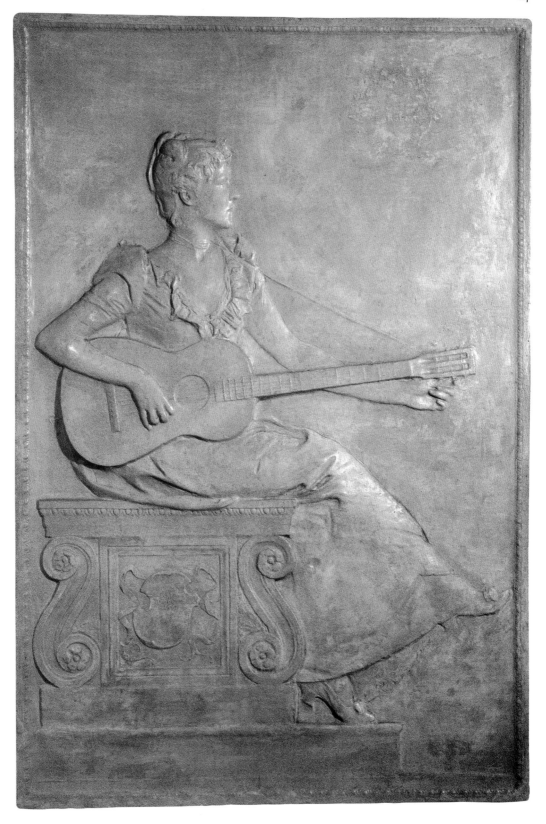

64. *Violet Sargent,* 1890. Plaster, 50¼ × 34¼ inches. Saint-Gaudens National Historic Site, Cornish, N.H. (SAGA no. 931).

The reliefs of the American artist John Singer Sargent and that of the French painter Jules Bastien-Lepage were the last ones Saint-Gaudens did in Paris. Bastien-Lepage's was Saint-Gaudens's first relief to be acquired by a museum, the Museum of Fine Arts, Boston, following its exhibition there in 1881. Although the Sargent relief (below) might be mistaken for a medal because of its size—it measures 2⅜ inches in diameter—it is actually a cast bas-relief. Diminutive yet powerful, it is a superb example of Saint-Gaudens's innovative style. The diminutiveness of this portrait was meant as a gentle joke, a contrast to Sargent's grand full-length painted portraits. The opportunity to do a full-length bas-relief came to Saint-Gaudens when John's sister Violet was introduced to American society in 1889 and 1890. In exchange for this 50¼ by 34¼–inch portrait (opposite), Saint-Gaudens received a 60 by 44–inch painting of Augusta Saint-Gaudens reading to their ten-year-old son Homer (now in the Carnegie Museum of Art, Pittsburgh).

The painter Will H. Low, whom Saint-Gaudens knew in Paris and in New York City, was a close friend of the Scottish author Robert Louis Stevenson (1850–94). It was Low who arranged the first meeting between the sculptor and the writer in 1887, when Stevenson was staying at the Hotel Albert; the two also met later at the St. Stevens Hotel in New York City. Here Saint-Gaudens began modeling the portrait of the author (see pages 106–7) that was finished later at Manasquan, New Jersey. After Stevenson moved to Samoa, the two never met again, but Stevenson wrote to Saint-Gaudens on July 8, 1894, after receiving the sculptor's bronze relief portrait of him, measuring 35 inches in diameter. Stevenson was pleased with the portrait, especially with the inclusion of the verses from *Underwoods,* a poem dedicated to Low, beginning "Youth now flees on feather foot" and ending "Life is over life was gay / We have come the primrose way."[10] Stevenson's death that same year brought with it renewed interest in his writings and set Saint-Gaudens to casting editions of his portraits in homage to his friend. In 1898, when he was in Paris, he began the reductions in the circular format, measuring 18 and 13 inches, and still later reduced versions of the rectangular reliefs. The market for such bronzes was especially good, and the sculptor had the foresight to offer them to the public until his death in 1907. His widow continued to issue editions of these works into the 1920s.

65. *John Singer Sargent,* 1880. Bronze and sand casting, 2½ inches diameter. Saint-Gaudens National Historic Site, Cornish, N.H. (SAGA no. 1613). Gift of Mr. and Mrs. Augustus Saint-Gaudens II, 1973.

65

66

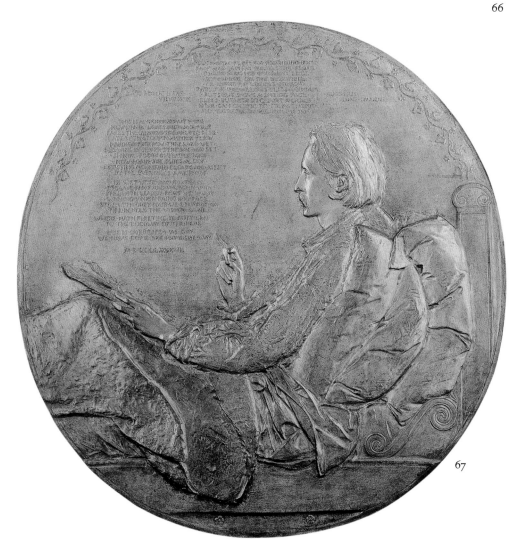

67

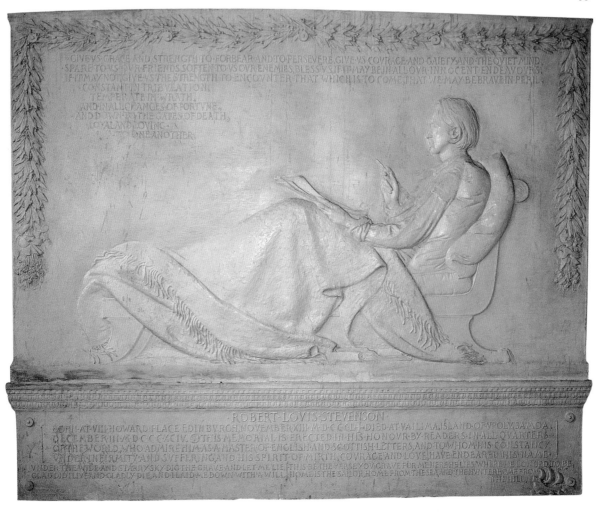

66. *Robert Louis Stevenson, First Version,* 1887–89. Gilded copper electrotype, 6⅝ × 13½ inches. Saint-Gaudens National Historic Site, Cornish, N.H. (SAGA no. 937).

67. *Robert Louis Stevenson, Second Version,* 1887–88. Bronze, 35⅜ inches diameter. Saint-Gaudens National Historic Site, Cornish, N.H. (SAGA no. 933).

68. *Robert Louis Stevenson, Third Version, Monumental,* 1899–1903. Plaster, 91 × 109 inches. Saint-Gaudens National Historic Site, Cornish, N.H. (SAGA no. 1657).

An important component of this exhibition is the monumental cast (see page 107) that was commissioned as the only memorial to Stevenson in his native land and was unveiled in St. Giles Church in Edinburgh, Scotland, in June 1904. This monumental plaster was first exhibited at the Pan-American Exposition in Buffalo in 1901. Here the sculptor recreated the earlier full-length portrait of the writer recumbent on a couch with quill pen (instead of the familiar cigarette), decorated along the top and sides with garlands of laurel entwined with Scottish heather and Samoan hibiscus and inscribed with lines from several of Stevenson's poems:

Give us grace and strength to forbear and to persevere . . .
Give us courage and gaiety and the quiet mind.
Spare to us our friends, soften us to our enemies.
Bless us, if it may be, in all our innocent endeavors.
If it may not, give us strength to encounter that which is to come,
That we may be brave in peril, constant in tribulation, temperate in wrath,
And in all changes of fortune, and to the gates of death,
Loyal and loving to one another.[11]

The popularity of the Stevenson reliefs brought an upsurge in patrons seeking a portrait in bas-relief by Saint-Gaudens. For instance, the three-quarter-length sculpture of the deceased Louise Miller Howland (see page 88), with its superb Renaissance-style frame designed by Stanford White, is worthy of special note as it is in such high relief, almost three-dimensional. Another relief, that of Stanford White's bride, Bessie Smith, was a wedding present from the sculptor. Carved originally in a three-quarter-length marble portrait, it was later cast in a bronze variant (opposite). The elegant, nearly full-length relief of the famous Philadelphia neurologist Dr. Silas Weir Mitchell (see page 110) is a mature example of Saint-Gaudens's mastery. The full-length portraits of the Jacob Schiff children (see page 114) were created at the midpoint of the sculptor's career. These works capture the full measure of the sculptor's creativity and genius in "painting a bas-relief." Their larger format provided the stage for his own special gift of creating motion and drama in his art. His final relief (see page 111), the unfinished portrait of his wife, Augusta Homer Saint-Gaudens, includes the landscape of Mt. Ascutney in the background, beautifully framed by the classical Doric columns of the pergola of his Cornish studio.

69. *Bessie Smith White,* 1884. Bronze, 19½ × 10½ inches. Saint-Gaudens National Historic Site, Cornish, N.H. (SAGA no. 2528). Gift of the Trustees of the Saint-Gaudens Memorial, 1978.

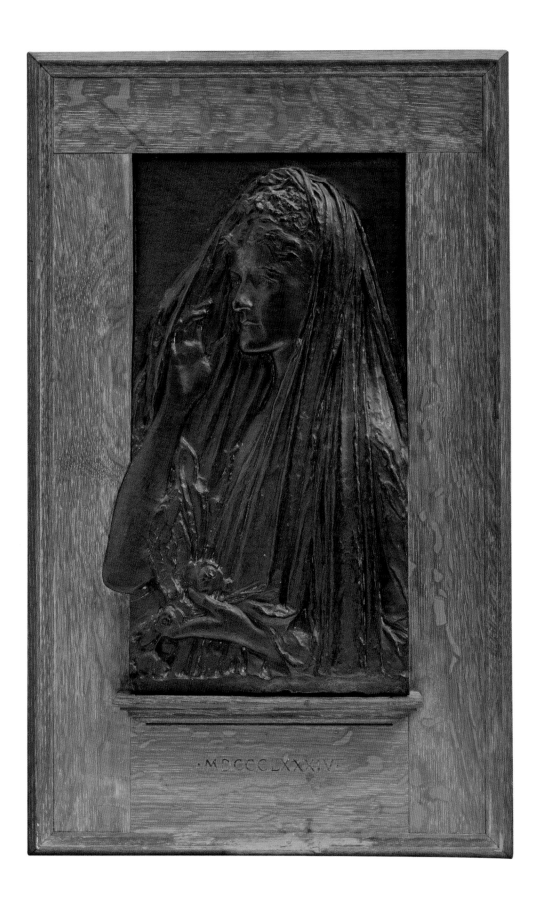

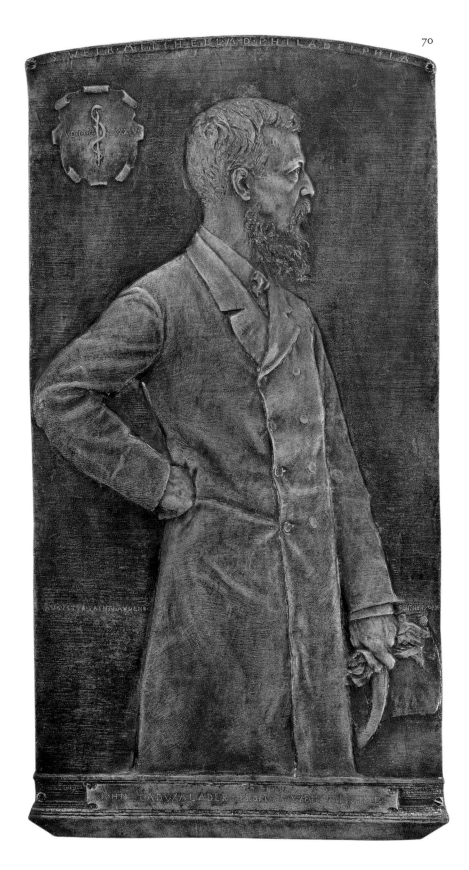

110

70. *Silas Weir Mitchell,*
1884. Bronze, 30½ ×
16⅝ inches. Mrs. Henry
Sherk.

71. *Augusta Homer Saint-
Gaudens,* 1905–7. Bronze,
35¹³⁄₁₆ × 23¼ inches.
Saint-Gaudens National
Historic Site, Cornish,
N.H. (SAGA no. 909).

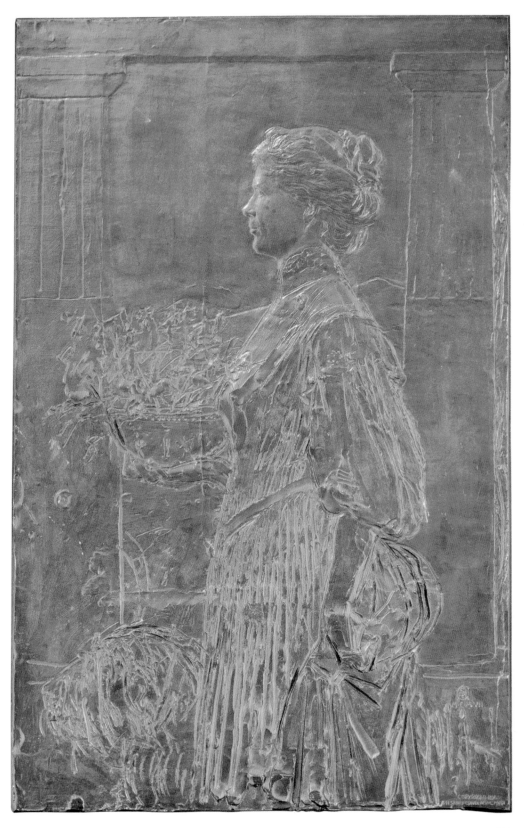

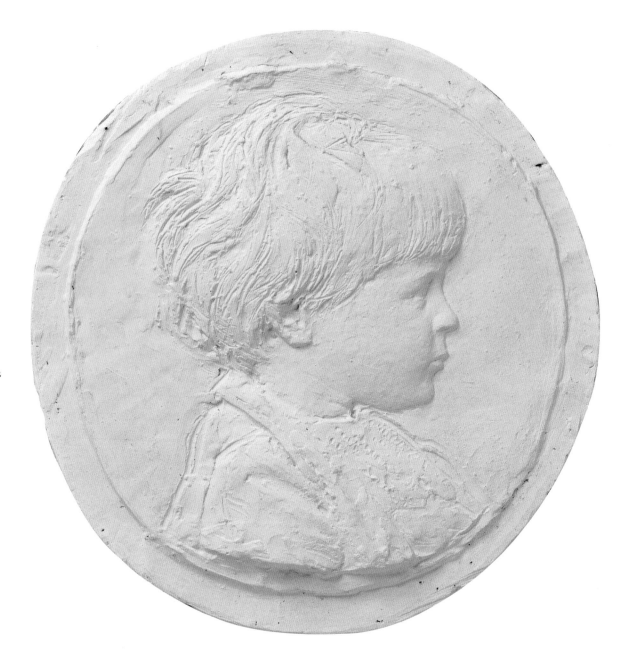

72. *"Novy," Study of a Child (Louis P. Clark),* 1892.
Plaster, 18¾ inches diameter. Saint-Gaudens National
Historic Site, Cornish, N.H. (SAGA no. 1251). Saint-
Gaudens's second son (b. 1889), by the model Davida
Johnson Clark, was named for the artist's brother.

73. *Homer Saint-Gaudens,*
1882. Bronze, 19½ ×
9⅞ inches. Saint-Gaudens
National Historic Site,
Cornish, N.H. (SAGA
no. 871). Saint-Gaudens's
portrait relief of his first
son at the age of seven-
teen months was a gift
to the artist's close
friend Dr. Henry Shiff.

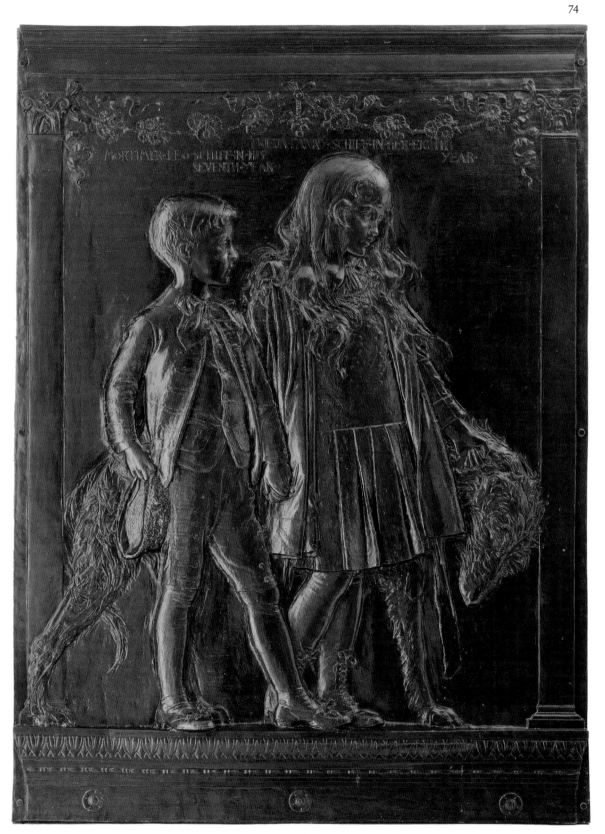

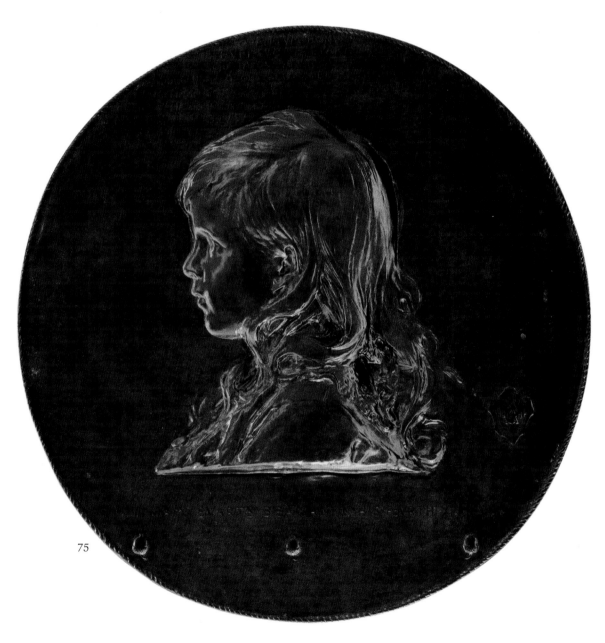

75

74. *Mortimer Leo and Frieda Fanny Schiff,* 1885. Bronze, 67⁵/₁₆ × 50³/₈ inches. Saint-Gaudens National Historic Site, Cornish, N.H. (SAGA no. 1647). Gift of John M. Schiff, 1969.

75. *William Evarts Beaman,* 1885. Bronze, 18½ inches diameter. Saint-Gaudens National Historic Site, Cornish, N.H. (SAGA no. 907).

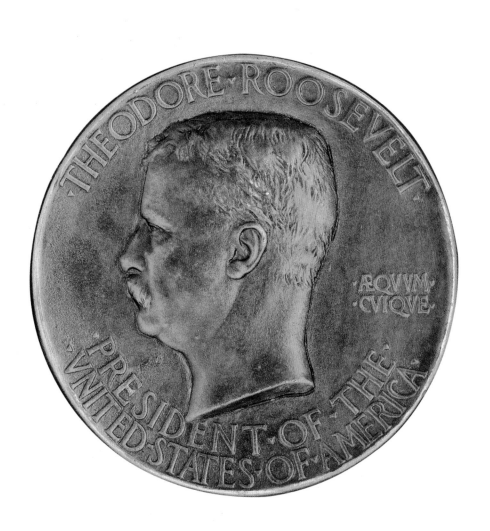

Saint-Gaudens was the first professional sculptor in the United States to produce designs for the nation's coinage. Commissioned by a special citizens committee following Theodore Roosevelt's election in 1904, Saint-Gaudens was asked to design an inaugural medal. Working with his assistant Adolph A. Weinman (1870–1952), Saint-Gaudens produced the medal, which was issued on March 5, 1905. Saint-Gaudens chose a head of Roosevelt for the obverse and a standing eagle for the reverse, combining the head with the inscription: AQVVM CVIQVE ("Square Deal") (opposite).

76. *Theodore Roosevelt Special Inaugural Medal,* 1905. Bronze, 2⅞ inches diameter. Modeled by Adolph A. Weinman, designed by Saint-Gaudens, and produced by Tiffany and Company, New York. The American Numismatic Society, New York (no. 1958.157.6).

Roosevelt was so pleased with the medal that he enlisted Saint-Gaudens in the effort to redesign the ten- and twenty-dollar gold pieces as well as the one-cent coin. By November 1905 Saint-Gaudens had already developed a design for the obverse, "a full-standing figure of Liberty," modeled after his *Victory* from the *Sherman Monument,* "striding forward as if on a mountain top." His idea, he wrote to Roosevelt, "is to make it a *living* thing and typical of progress."[12] Both men were inspired by the coins of ancient Greece.

When stricken with cancer, Saint-Gaudens acquired help in the studio from Henry Hering (1874–1949), a young sculptor who had studied under him at the Art Students League and had returned from Paris in 1901. Hering worked full-time on the coins. By May 1906 the twenty-dollar coin was well along, and Saint-Gaudens began to design the one-cent piece.

Roosevelt urged that a figure of Liberty with a Native American headdress be used on one of the coins, and Saint-Gaudens adopted the idea for the ten-dollar coin in May 1907. He designed a standing eagle for the reverse, similar to the one he had used on the Roosevelt medal. For the twenty-dollar piece Saint-Gaudens used the flying eagle, which was inspired by the eagle on the 1856 one-cent piece and which he had originally planned to use on his own one-cent design. The one-cent piece, although completed in the model stage, was never minted. However, it is captured in the bronze relief entitled *NIKH-EIPHNH* (see page 73).

Saint-Gaudens died on August 3, 1907. President Roosevelt, determined to see the ten- and twenty-dollar pieces in circulation before 1908, gave the order to the secretary of the treasury to begin issuing the gold coinage by September 1. The ten-dollar coins (opposite top) were issued first, since workable dies for these coins existed. The twenty-dollar dies were not ready, however, and in November 1907 Roosevelt issued the order to begin minting the twenty-dollar piece even if it took all day and night to issue one.

Two successive issues of the "Double Eagles" (opposite bottom) came into circulation before December 14, struck on the medal presses at the U.S. Mint. Notable for their sharp wire rims, they are much sought after to this day. Roosevelt's joy in the early strikes of the coins is evident in his correspondence and the pleasure he took in distributing them. He spoke of the coinage in his memoirs as one of the important achievements in his administration. However, he gave all the tribute to Saint-Gaudens, often commenting that the coins were "more beautiful than any coins since the days of the Greeks."[13]

Roosevelt's collaboration with Saint-Gaudens engendered a legacy of fine coin designs among Saint-Gaudens's students and assistants: James Earle Fraser's "Buffalo Nickel"; Bela Pratt's "Half- and Quarter-Eagles," two-and-one-half-dollar gold piece and five-dollar gold piece with their adventurous incuse (relief in reverse) designs; Adolph Weinman's "Mercury Dime" and "Walking Liberty Half-Dollar"; John Flanagan's "Washington Quarter"; and Charles Keck's commemorative coin. The 1907 United States coinage well deserves the praise of collectors and scholars everywhere. Still considered the most beautiful coin ever minted in the United States, Saint-Gaudens's "Double Eagle" design was resurrected in 1987 for the gold bullion piece issued by the U.S. Mint and is still in production.

The continued popularity of Saint-Gaudens's twenty-dollar gold coin, the only twenty-dollar gold coin to be acknowledged officially by the U.S. Mint as legal tender, was reaffirmed on July 30, 2002, when the only surviving example of the 1933 issue was sold at Sotheby's auction house in New York City for $7.59 million.

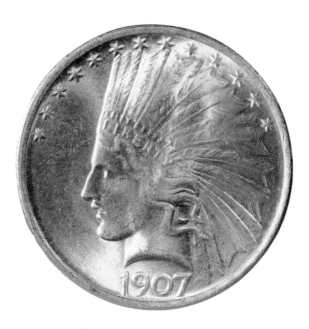

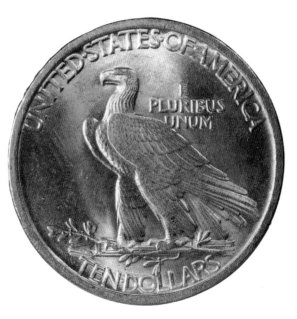

77. *United States Ten-Dollar Gold Piece ("Eagle") (obverse)*,
1907. Gold (early proof strike with a wire rim),
1¹/₁₆ inches diameter. The American Numismatic
Society, New York (no. 1980.109.2279).

78. *United States Ten-Dollar Gold Piece ("Eagle") (reverse)*,
1907. Gold (low-relief business strike), 1¹/₁₆ inches
diameter. The American Numismatic Society, New
York (no. 0000.999.4575).

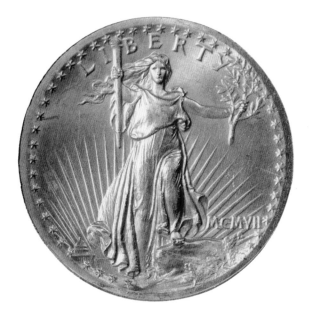

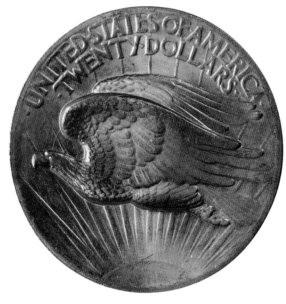

79. *United States Twenty-Dollar Gold Piece
("Double Eagle") (obverse)*, 1907. Gold (high relief),
1⁵/₁₆ inches diameter. The American Numismatic
Society, New York (no. 1980.109.2101, 1937.61.3).

80. *United States Twenty-Dollar Gold Piece ("Double
Eagle") (reverse)*, 1907. Gold (low-relief business strike),
1⁵/₁₆ inches diameter. The American Numismatic
Society, New York (no. 1980.109.23.28).

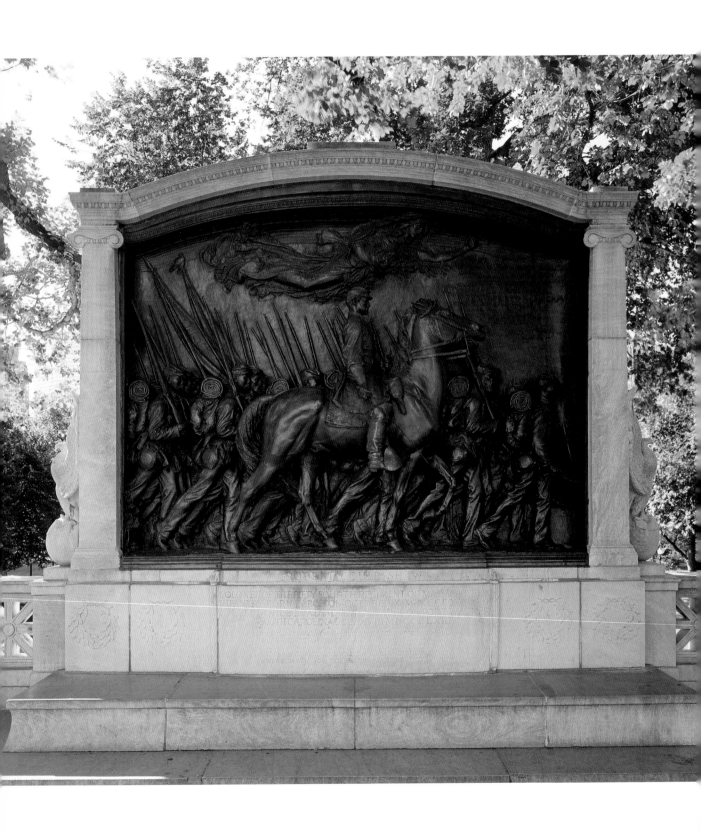

NOTES

AMERICAN SCULPTOR OF THE GILDED AGE

HENRY J. DUFFY

1. The literature on Augustus Saint-Gaudens is extensive. The catalogue raisonné is John H. Dryfhout's *The Work of Augustus Saint-Gaudens* (Hanover, N.H., and London: University Press of New England, 1982). The most recent comprehensive study is from the Musée des Augustins, Toulouse, and Musée national de la Coopération franco-américaine, Chateau de Blérancourt, *Augustus Saint-Gaudens, 1848–1907: A Master of American Sculpture* (Paris: Somogy Éditions d'Art, 1999).

2. Henry S. Commager, Book World, February 8, 1970, p. 10.

3. Saint-Gaudens perfected the technique of low-relief portrait sculpture, the subject of an important exhibition at the National Portrait Gallery in 1969. See John H. Dryfhout and Beverly Cox, *Augustus Saint-Gaudens: The Portrait Reliefs* (Washington, D.C.: National Portrait Gallery, Smithsonian Institution, 1969).

4. Adeline Adams (1859–1948), wife of the sculptor Herbert Adams (1858–1945) and author of numerous writings about sculpture, described this quality of Saint-Gaudens's work in *The Spirit of American Sculpture* (New York: The National Sculpture Society, 1929): "[H]e never forgot that the snare of the picturesque was in his path, as it is in the path of every sculptor trying to infuse a

genial human warmth into the sculptural order" (p. 48). The Adamses were both friends and neighbors of Saint-Gaudens in Cornish, N.H. The idea that the genre quality so admired in painting was inappropriate to sculpture was repeated in a *New York Times* review of Saint-Gaudens's portrait *Theodore Dwight Woolsey* at Yale University. The reviewer admired the portrait but not the very large sleeves of the man's academic gown. "It may be questioned, nevertheless, whether Mr. Saint-Gaudens was wise to make so much of the gown with puffed sleeves. It looks as if this part were a concession to some desire on the part of the purchaser or sitter, rather than the proposition of the sculptor; for Saint-Gaudens could hardly fail to understand that so much obtrusion of what is called in sculptor slang the 'picturesque' would detract to a certain extent from the nobility of the face" ("Varnishing Day Scenes," *New York Times*, March 16, 1880).

5. The first serious criticism of Saint-Gaudens came in 1881, with two articles by the poet and editor Richard Watson Gilder (1844–1909) and the art critic Mariana Griswold Van Rensselaer (1851–1934) about the newly dedicated *Farragut Monument*. See Richard W. Gilder, "The Farragut Monument" *Scribner's Magazine* 22 (June 1881): 161–167; and Mariana G. Van Rensselaer, "Mr. St. Gaudens's Statue of Admiral Farragut in New York," *American

Architect and Building News 10 (September 10, 1881): 119–20. Van Rensselaer later wrote an important essay about the *Standing Lincoln* in Chicago; see "St. Gauden's Lincoln," *Century Magazine* 35 (November 1887): 37–39. These three articles were significant in the history of American art, as well as important for Saint-Gaudens' career, as they spoke seriously and completely about the artistic and spiritual qualities that made the two monuments not only "modern" but also seminal in the development of American art. The two critics became close friends of the sculptor. Saint-Gaudens created portrait reliefs of both, Gilder's portrait in 1879, and Van Rensselaer's in 1888. Gilder wrote the epic poem "The Fire Divine" in 1907 in memory of Saint-Gaudens.

6. Saint-Gaudens paints an amusing picture of his father's creative approach to business in *The Reminiscences of Augustus Saint-Gaudens*, ed. Homer Saint-Gaudens, 2 vols. (New York: Century, 1913), 1:12–17.

7. Ibid., 1:129, 285.

8. The art world of New York City before the Civil War is described in Catherine Hoover Voorsanger and John K. Howat, eds., *Art and the Empire City: New York, 1825–1861* (New York: The Metropolitan Museum of Art and Yale University Press, 2000), The three essays of special interest are John K. Howat, "Private Collectors and Public Spirit: A Selective View," 83–108; Thayer

Tolles, "Modeling a Reputation: The American Sculptor and New York City," 135–68; and Carrie Rebora Barratt, "Mapping the Venues: New York City Art Exhibitions," 47–82.

9. Olin Levi Warner (1844–1896) and Howard Roberts (1843–1900) were, along with Saint-Gaudens, the first Americans to study sculpture in Paris at the École des Beaux-Arts. They studied with François Jouffroy (1806–82), a member with Saint-Gaudens's friends Paul Dubois (1829–1905) and Antonin Mercié (1845–1916) of the Neo-Florentine circle of artists in Paris. Associated with the Néo-Grecs of Jean-Leon Gérôme in painting (also greatly admired by Saint-Gaudens), these artists were seeking to recapture the style of the Renaissance, combining the classical with the living, "breathing" quality of the Renaissance. This is significant as a basis for Saint-Gaudens's later style. See Édouard Papet, "Saint-Gaudens and France," in *Augustus Saint-Gaudens (1848–1907): A Master of American Sculpture,* 23–30.

10. The influence of impressionism on Saint-Gaudens is largely unexplored. He spoke and wrote against it, yet the style is reflected especially in his later reliefs, works in which the surface texture is manipulated in such a way to capture and direct light.

11. In the *Reminiscences,* Saint-Gaudens's son Homer describes the majority of American sculptors in this early time as "mostly craftsmen rather than thinkers" (1:58). The question of why an American would leave the country for training is addressed by his son: "At first glance it might be thought that . . . there surely could be no vital need for Saint-Gaudens to leave this land. . . . But on a little consideration it becomes obvious that, though there were many who were learning, as yet no capable men had arrived at that stage where they either cared to teach, or were able to do so" (1:59).

12. Lorado Taft, *The History of American Art* (New York: MacMillan, 1917); see particularly the chapter "The History of American Sculpture."

13. Just before and after the Civil War the newspapers were full of stories about the perceived weakness of American art in relation to European art. Most writers equated artistic merit with monetary value. Their own doubt in recognizing real from forged European art was also a basis for their criticism. If they were unable to recognize true artistic quality, they tended to push the art aside. This is one reason that genre art became dominant: anyone could understand and clearly see what was being depicted. An article in the *New York Times* on April 1, 1873, stated: "Art, we may all admit, is cosmopolitan, and as regards the artist, we do not ask where he was born, but how good is his work. If better pictures can be brought from abroad than our own artists can produce, and sold for less money than our own artists can afford to paint for, there is manifestly good reason for such importations. But when so many really good American painters wait so long for recognition, when they are pushed to the wall and their work neglected in favor of canvases from overseas of inferior merit, it is right to expostulate and to combat the evil."

14. In an article entitled "American and Foreign Art: Our Shortcomings," which appeared in the *New York Times* on May 18, 1873, the reviewer questioned the predominance of the Hudson River School, wondering why European artists "find opportunity to paint . . . the grander phases and more striking combinations of nature." He admired Frederic Church (1826–1900) and Albert Bierstadt (1830–1902) but found that "Lake George and Newport, the Adirondacks and the White Mountains have been produced and reproduced until the public is absolutely sick of them; but places of historical interest . . . are never touched." Coming just six years after Saint-Gaudens left for Europe, this article indicates that popular taste was in transition. The America Saint-Gaudens returned to had made a radical shift in taste.

15. David Maitland Armstrong, painter and diplomat, describes this moment of time in *Day Before Yesterday: Reminiscences of a Varied Life* (New York: Charles Scribner's Sons, 1920), 258–87. Armstrong was significant in Saint-Gaudens's career as a friend as well as a catalyst. His own contacts allowed him to introduce Saint-Gaudens to potential clients as well as to artist friends who had a major impact on the sculptor's career.

16. Armstrong, quoting the *New York Times,* in *Day Before Yesterday,* 269–70.

17. The point cannot be stressed too much. The names of the artists that Saint-Gaudens attracted to his circle

form a compendium of modernism. Whether in painting, literature, architecture, or sculpture, these were all people who were pushing the boundaries of culture, creating a cosmopolitan world that was neither European nor American, but the best of both. The people who sat for portraits by Saint-Gaudens were a specific group of artists and literary persons who were promoting modernism in the arts, ranging from the writer William Dean Howells to the art critic Mariana Van Rensselaer.

18. This debate took tangible form in 1877 with the founding of the Society of American Artists. Unhappy with the National Academy's rejection of one of his sculptural figures, Saint-Gaudens founded the society in June 1877 at the house of the editor Richard Watson Gilder, with his wife, the painter Helena DeKay Gilder, and the artists Walter Shirlaw and Wyatt Eaton. In subsequent years the organization included R. Swain Gifford, Louis C. Tiffany, Olin Warner, Homer D. Martin, Samuel Coleman, John La Farge, Thomas Moran, J. Alden Weir, Thomas Eakins, Eastman Johnson, George Inness, and Alexander Wyant, among others. The society exhibited the work of women artists as well as artists who followed no formal style, such as Albert Pinkham Ryder. The critic Clarence Cook attended the first meeting and wrote the opening review of the new group; see *Reminiscences* 1:184–89. The society remained active for about twenty years before being absorbed into the National Academy. The two organi-

zations working simultaneously created a great deal of public debate about art and the question of what was truly American in the newer work exhibited by the society.

19. Although Augustus Saint-Gaudens spelled his name variously, sometimes leaving out the hyphen and sometimes using the abbreviation "St.," he most frequently spelled it "Saint-Gaudens." To distinguish himself, his sculptor brother Louis (1854–1913) always used the abbreviated form—St. Gaudens. However, the public seemed unaware of the distinctions, and even critics sometimes misspelled the name. Augustus could make light of his name, allowing his close associates to call him "the Saint." His son Homer (1880–1958), like his father, always used the hyphen and the full spelling.

20. Taft, 9.

21. Nineteenth-century French sculpture is discussed in many sources. See, for instance, Maurice Rheims, *Nineteenth Century Sculpture* (Paris: Arts et Métiers Graphiques, 1972), which was later translated by Robert E. Wolf (New York: Harry N. Abrams, 1977). Taft and other contemporaries all saw the importance of French art as a turning point in the development of American art. It was a true cultural break as sculptors such as Warner and Saint-Gaudens studied with innovative French artists who were themselves breaking with tradition. The influence on Saint-Gaudens of art movements such as the Pre-Raphaelites and impressionism has not yet been fully explored. Although he toyed with Pre-Raphaelite style in the

Morgan tomb angels and the *Amor Caritas,* he soon abandoned it. Impressionism was something he spoke of negatively, and yet it is visible clearly in his portrait reliefs.

22. It is interesting that a number of these artists were also familiar with the Barbizon school in France.

23. Taft, 9.

24. Ibid., 222–23. It is here that Taft describes Saint-Gaudens as "artless."

25. Chandler Rathfon Post, *A History of European and American Sculpture from the Early Christian Period to the Present Day* (Boston: Harvard University Press, 1921).

26. *New York Times,* December 21, 1887, in an article about the painter George Inness. This concept is more fully described in Henry J. Duffy, "New York City Collections 1865–1895" (Ph.D. diss., Rutgers, 2001).

27. Post, 242–43. There were other artists who shared these qualities: Taft describes Olin Warner as following a similar beginning, also studying in France with Jouffroy, Carpeaux, Falguière, and Mercié as well as participating in French history as a member of the Foreign Legion fighting during the Commune in 1870. Back in America in 1872, he found no place for his sculpture, and it forced him back to his farm, where he essentially gave up art entirely. He returned in 1878 with a partnership with Daniel Cottier in New York.

28. Taft, 268ff. The statement about *The Garrison* appears on p. 273. Contemporary critics, who could see the almost identical French training and the effect that it had on both artists linked Warner and Saint-

Gaudens. One article described their election as members of the National Academy of Art and what that might mean to their role as founding members of the Society of American Artists. A critic in the *New York Times* wrote on May 20, 1889: "The election to the rank of National Academician of the sculptors St. Gaudens and Olin Warner is only justice, if a somewhat tardy justice, done to a couple of artists identified with a movement which was once a protest against the stagnation of the Academy. The older institution has at last seen the wisdom of absorbing the better element among the younger men who once objected to its ways. What affect this policy will have upon the Society of American Artists remains to be seen. This year's exhibition of the society is not inferior but superior to others gone before; at the same time the Academy can always secure the best work of any artist, provided steps are taken to encourage him, because artists must live, and the Academy exhibitions remain the best market for work. Yet it would be a thousand pities were the younger society to lose heart and surrender its yearly shows, for it has been most effective in keeping the older up to the mark."

29. The letter, dated February 21, 1881, is part of the artist's papers preserved at Dartmouth College, Special Collections. The text is given in *The Reminiscences of Augustus Saint-Gaudens*, edited and amplified by Homer Saint-Gaudens (New York: Century, 1913), 1: 278.

30. Will H. Low, *A Chronicle of Friendships 1873–1900* (New York:

Charles Scribner's Sons, 1908), 505.

31. *Reminiscences,* 2:16.

32. Saint-Gaudens's teaching style is described in the *Reminiscences*, 2:3–39. Saint-Gaudens was an inspirational but tough teacher. His temper could be explosive, but his assistants and pupils all found his personal attention and seriousness to be energizing. The author Royal Cortissoz (1869–1948) summarized: "It was a fine thing that he was generous in encouragement, that he went out of his way to praise and help; but I think it was even finer that he created around himself a stimulating atmosphere, and somehow made one feel that what he must take as a matter of course was the hardest kind of hard work and the highest possible standard of excellence. I do not know how better to express the ideal that he stood for than to say that from the Saint-Gaudens point of view the doing of a scamped or insincere piece of work was a fairly shameful performance, a kind of moral wrong." Quoted in Lorado Taft, "Augustus Saint-Gaudens," *Modern Tendencies in Sculpture: The Scammon Lectures at the Art Institute of Chicago, 1917* (Chicago: University of Chicago Press, 1917), 116.

33. Saint-Gaudens deserves credit for supporting men and women equally at a time when that was not usually the case. He was really concerned only with the drive to achieve the ideal in art.

34. The letter is to Isabel Moore Kimball, dated December 17, 1905. The letter is quoted in *Reminiscences*, 2:39. Kimball became a sculptor,

studying with Herbert Adams. Her works include *The Fountain* in Winona, Minnesota, the *Richards Tablet* at Vassar College, and the *War Memorial Tablet* for Essex County, New York. She exhibited at the National Association of Women Painters and Sculptors in New York City in 1924. Her studio was on Fulton Street in Brooklyn.

35. Saint-Gaudens built a small private studio just inside the forest at the edge of the lawn at Aspet, in Cornish, N.H., to serve a special need as a retreat for members of the studio. It is a subtle point but characteristic of Saint-Gaudens to recognize the need for both group interaction and privacy in the creative process. The small studio is used to this day as the workshop of the sculptor in residence at the Saint-Gaudens National Historic Site.

36. The National Sculpture Society, founded in 1893 by Saint-Gaudens, Richard Morris Hunt, Daniel Chester French, and others, was a crucial link in the developing concept to provide adequate support for American sculptors. As he and Armstrong had done in Paris, works for society exhibits were chosen by a jury of peers, not according to political or social standing. Founded in the same year as the World's Columbian Exposition in Chicago and a year before the initiation of the idea for the American Academy in Rome, the National Sculpture Society was part of a larger drive by Saint-Gaudens and others to formalize the training and support systems for artists in America, using a democratic inclusiveness not found in European counterparts.

37. The Mall was given particular attention by the committee. The Lincoln Memorial site is believed to have been chosen with Saint-Gaudens's involvement. The sculptor was also the driving force behind placing limitations on the proliferation of monuments in Arlington Cemetery on the hillside by the Lee Mansion. He was also an adviser on the decoration of the Library of Congress. See *Report on the Senate Committee on the District of Columbia on the Improvement of the Park System of the District of Columbia, U.S. Senate Committee on the District of Columbia,* 57th Congress, 1st Session, 1902, S. Rept. 166.

38. For the founding of the American Academy, see Henry J. Duffy, "Augustus Saint-Gaudens and the Founding of the American Academy in Rome," *Essays in Honor of Matthew Baigell's Retirement from the Department of Art History, Rutgers University* (Philadelphia: 90th Annual College Art Association Conference, 2002). The effort became one of the sculptor's last concentrated attempts to provide for the new generation of artists. He wanted there to be a place where Americans could absorb the artistic wealth of Rome while being free of the care of the simple logistical problems of a young artist in a foreign country. Saint-Gaudens himself was essentially "on his own" in Rome as a young man and no doubt remembered how difficult it was to find studio space and earn sufficient money to maintain his studies.

THE CATALOGUE

JOHN H. DRYFHOUT

1. *The Reminiscences of Augustus Saint-Gaudens,* ed. Homer Saint-Gaudens, 2 vols. (New York: Century, 1913), 2:78–79.

2. John Loring, *Magnificent Tiffany Silver* (New York: Harry N. Abrams, 2002), 118–19.

3. For an explanation of the spelling of Saint-Gaudens's name, see Henry J. Duffy, "American Sculptor of the Gilded Age," note 19, in this volume.

4. Rose Standish Nichols, "Familiar Letters of Augustus Saint-Gaudens," *McClure's Magazine* 31, no. 6 (October 1908): 603–16.

5. See *Hope and Glory: Essays on the Legacy of the Fifty-fourth Massachusetts Regiment* (Amherst, Mass: University of Massachusetts Press and the Massachusetts Historical Society, 2001) and Gregory Schwarz, Ludwig Lauerhass, and Brigid Sullivan, eds., *The Shaw Memorial: A Celebration of an American Masterpiece* (Cornish, N.H.: Eastern National, 2002).

6. Quoted in John H. Dryfhout, *The Work of Augustus Saint-Gaudens* (Hanover, N.H., and London: University Press of New England, 1982), 158.

7. James E. Fraser, "America Again" (chapter 7), in "Autobiography," p. 3, Papers of James Earle Fraser, Syracuse University Library.

8. Thayer Tolles, "Refined Picturesqueness: Augustus Saint-Gaudens and the Concept of 'Finish,'" in Musée des Augustins, Toulouse, and Musée national de la Coopération franco-américaine, Chateau de Blérancourt. *Augustus Saint-Gaudens, 1848–1907: A Master of American Sculpture* (Paris: Somogy Éditions d'Art, 1999), 59.

9. Saint-Gaudens, *Reminiscences,* 2:23.

10. Robert Louis Stevenson, "To Will H. Low," *Underwoods,* 11 (New York: Charles Scribner's Sons, 1887), 21–23.

11. To create his inscription, Saint-Gaudens selected excerpts from several of Stevenson's poems. The phrase in the actual poem is "home from sea." Saint-Gaudens inscribed the phrase as "home from the sea," and that is now the way the poem is remembered.

12. See John H. Dryfhout et al., *The 1907 United States Gold Coinage* (Cornish, N.H.: Eastern National, 2002).

13. From President Theodore Roosevelt's remarks at the opening of the *Memorial Exhibition of the Works of Augustus Saint-Gaudens,* organized by the American Institute of Architects at the Corcoran Gallery of Art, Washington, D.C, on December 15, 1908. Quoted in John W. Bond, "Augustus Saint-Gaudens: The Man and His Art" (unpublished report, Office of Archeology and Historic Preservation, Division of History, National Park Service, U.S. Department of the Interior, Washington, D.C., October 18, 1967), 273.

SOURCES

Bond, John W. "Augustus Saint-Gaudens: The Man and His Art." Office of Archeology and Historic Preservation, Division of History, National Park Service, U.S. Department of the Interior, Washington, D.C., October 18, 1967.

Dryfhout, John H. *The Work of Augustus Saint-Gaudens.* Hanover, N.H., and London: University Press of New England, 1982.

Dryfhout, John H., and Beverly Cox. *Augustus Saint-Gaudens: The Portrait Reliefs.* Washington, D.C.: National Portrait Gallery, Smithsonian Institution, 1969.

Dryfhout, John H., and Diana Stevenson. *Metamorphoses in Nineteenth-Century Sculpture.* Cambridge, Mass.: Fogg Art Museum, 1975

Dryfhout, John H., et al. *The 1907 United States Gold Coinage.* Cornish, N.H.: Eastern National, 2002.

Greenthal, Kathryn. *Augustus Saint-Gaudens: Master Sculptor.* New York: The Metropolitan Museum of Art, G. K. Hall, 1985.

Musée des Augustins, Toulouse, and Musée national de la Coopération franco-américaine, Chateau de Blérancourt. *Augustus Saint-Gaudens, 1848–1907: A Master of American Sculpture.* Paris: Somogy Éditions d'Art, 1999.

Saint-Gaudens, Homer, ed. *The Reminiscences of Augustus Saint-Gaudens.* 2 vols. New York: Century, 1913. Reprint, with an introduction by H. Barbara Weinberg, New York: Garland, 1976.

Sanderson, Paul G., III. *Augustus Saint-Gaudens: An American Original.* Our Town Films, 1985.

Schwarz, Gregory, Ludwig Lauerhass, and Brigid Sullivan. *The Shaw Memorial: A Celebration of an American Masterpiece.* Washington, D.C.: Eastern National, 2002.

Tharp, Louise Hall. *Saint-Gaudens and the Gilded Era.* Boston: Little, Brown, 1969.

Timreck, T.W. *Saint-Gaudens: Masque of the Golden Bowl.* Spofford Films, 1985.

Wilkinson, Burke. *Uncommon Clay: The Life and Works of Augustus Saint-Gaudens.* New York: Harcourt Brace Jovanovich, 1985.

All original material relating to Saint-Gaudens—letters, documentation concerning his home and studio, photographs, family memorabilia, and other items—are in the Rauner Special Collections Library, Dartmouth College, Hanover, New Hampshire.

INDEX OF WORKS

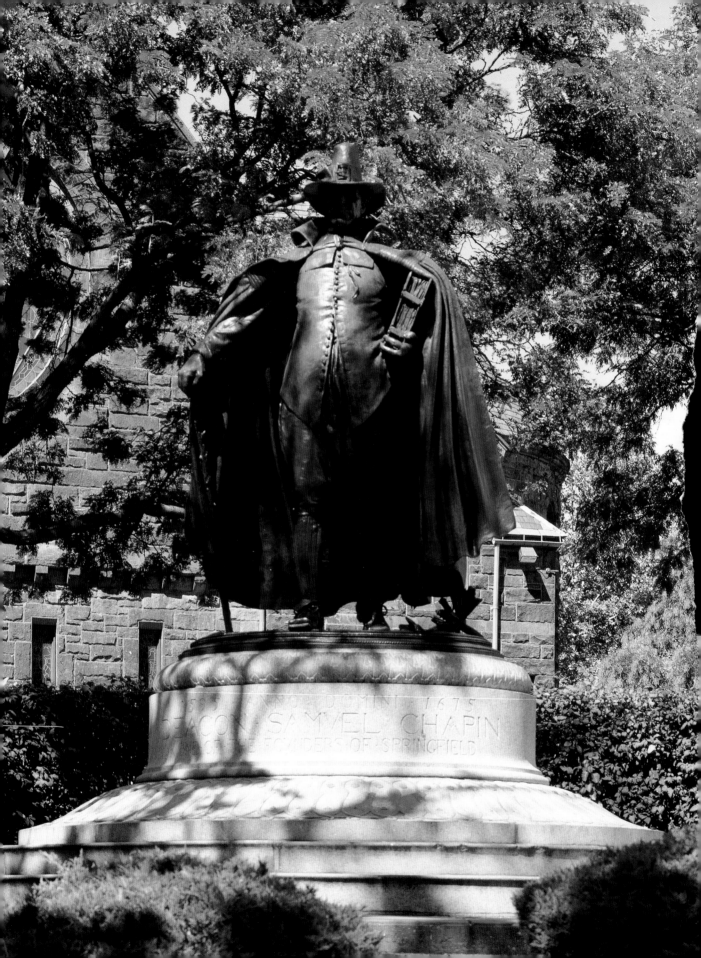